YOUR JEWISH LEXICON

Presented to

Barbara Dolinger

with much appreciation from
Am Shalom School
May, 2000

YOUR JEWISH LEXICON

Some Words and Phrases in Jewish Life and Thought in Hebrew and in English

Edith Samuel

Union of American Hebrew Congregations
New York

The author and publisher thank the following for permission to reprint:

Central Conference of American Rabbis from *Gates of Prayer: The New Union Prayerbook* © 1975; *Gates of the House: The New Union Home Prayerbook* © 1976; *Gates of Repentance: The New Union Prayerbook for the Days of Awe* © 1978.

Jewish Publication Society of America from *The Holy Scriptures According to the Masoretic Text* (1917 translation) © 1955; *The Torah: The Five Books of Moses* © 1962; *The Five Megilloth and the Book of Jonah* © 1969; *The Book of Psalms* © 1972; *The Prophets: Nevi'im* © 1978.

Schocken Books, Inc., from *The Ethics of the Talmud: Sayings of the Fathers*, edited by R. Travers Herford, © 1945 by Jewish Institute of Religion, © 1962 by Schocken Books, Inc.; *A Rabbinic Anthology*, selected and arranged by C. G. Montefiore and H. Loewe, © 1974.

Composition by Bet Sha'ar Press, Inc.

Library of Congress
Catalog Card No.: 81-71310
Samuel, Edith.
Your Jewish lexicon.
NY: Union of American Hebrew Congregations
175 p.
8206 811113

Manufactured in the United States of America
10 9 8 7 6 5 4 3

Feldman Library

The Feldman Library Fund was created in 1974 through a gift from the Milton and Sally Feldman Foundation. The Feldman Library Fund, which provides for the publication by the UAHC of selected outstanding Jewish books and texts, memorializes Sally Feldman, who in her lifetime devoted herself to Jewish youth and Jewish learning. Herself an orphan and brought up in an orphanage, she dedicated her efforts to helping Jewish young people get the educational opportunities she had not enjoyed.

In loving memory of my beloved wife Sally
"She was my life, and she is gone;
She was my riches, and I am a pauper."

"Many daughters have done valiantly, but thou excellest them all."

Milton E. Feldman

Editor's Introduction

For over twenty years, the Union of American Hebrew Congregations had been blessed by the genius of Mrs. Edith Samuel. Her personal commitment to Jewish learning and uncompromising standards of scholarship have moved thousands upon thousands of Jews to delve into our tradition and discover a special sense of Jewish literacy and belonging.

Edith Samuel's *Your Jewish Lexicon* will draw you into the exciting world of Jewish values as expressed through Hebrew, the *leshon ha-kodesh*. Each of the seventy-two articles informs, inspires, and evokes a vivid understanding of that precious heritage belonging to every Jew.

We are grateful to those whose careful reading of the text strengthened and enriched the book: Ms. Gwen Vallely, Mrs. Gerry Gould, Rabbi Bernard M. Zlotowitz, Rabbi Leonard A. Schoolman, and Rabbi Steven M. Reuben. We also express thanks to Ralph Davis and Stuart L. Benick for transforming the original manuscript into the volume you now hold in your hands.

We hope that *Your Jewish Lexicon* will help high school, college, and adult readers to know their Judaism and, through study, to know themselves a little better as Jews as well. We are proud to add it to our UAHC library of publications.

Daniel B. Syme, National Director
UAHC Department of Education

Contents

Author's Introduction

Why a Jewish Lexicon?

I

Like every family, the extended family we call the Jewish people possesses an intra-mural vocabulary. Over the centuries, we Jews have evolved a special vocabulary of Hebrew words and phrases that denote Jewish ideas, values, and outlook—words that bind us together as a people and help us to reinforce our identity as Jews.

The Hebrew language, even during the centuries when it was not used in daily life and was reserved for prayer and scholarship, provided the scattered Jewish people with a matrix of shorthand words through which understanding of the folk heritage was transmitted from community to community, generation to generation. Most of these words derived from the religious and cultural life of the people; such was their force that, even when masses of Jews no longer could read the Hebrew prayer book or Bible or, for a variety of reasons, no longer took part in religious services, knowledge of the intramural vocabulary remained alive in their homes.

Nowadays, many North American Jews have begun to explore their Jewish heritage. Some have returned to the synagogue and are eager to be able to read and understand Hebrew prayers. They send their children to religious school to learn what they never learned. Within the Reform movement, there is a steadily increasing number of men and women who are enrolling in adult *bar/bat mitzvah* study programs. Within both the Reform and Conservative movements in North America, there is a noticeable rise in adult Hebrew-learning programs. The new series of Union prayer books prepared by the Central Conference of American Rabbis for the Reform movement contains much more Hebrew than previous Reform Jewish prayer books.

But, ironically, learning modern Hebrew—as some adult Hebrew students are discovering—does not necessarily uncover the Jewish meanings of all the terms in our intramural vocabulary. The Hebrew language itself has undergone extensive changes in its long history. New coinages, particularly scientific and technological terms, are completely devoid of Jewish content; older words, as happens with any living language, are at times invested with new meanings or else drop out of daily use. Thus, if you consult a contemporary Hebrew-English dictionary like the

popular *New Bantam-Megiddo Hebrew and English Dictionary*, you will find that some of our intramural terms do not appear. For example, the principle of *piku'ach nefesh*, a supremely important Jewish concept, cannot be found as a phrase. *Nefesh* means "soul, spirit of life, person." *Piku'ach* is defined as "supervision." By combining the two translations, you get a nonsense phrase: supervision of the soul. Actually, *piku'ach nefesh* means "saving life." The obligation to save human life is so imperative in Jewish thought that even the strict Shabbat laws prohibiting work must be set aside to rescue endangered persons.

The popular Hebrew-English dictionaries that I have seen also fail to give nuances of Hebrew usage. For instance, in Hebrew, Jews never "immigrate" to the State of Israel; they "rise up, ascend" to Israel. They go "on *aliyah*," or they "make *aliyah*," meaning that they "go up." Similarly, in Hebrew, Jews never "leave" or "emigrate from" Israel; they "descend." To understand this oddity, you must bear in mind the topography of Israel, the location of the city of Jerusalem high in the Judean Hills—and the eternal centrality and sanctity of the city of Jerusalem in the Jewish heart.

Any Jewish lexicon, I believe, should help Jews know more of their Jewish heritage by examining some of the religious, cultural, and intellectual ideas compacted within certain Hebrew words and phrases. The *need* for such a lexicon for English-speaking Jews is self-evident. Jews who have been separated from their heritage and their intramural language now seek reform. Converts to Judaism—of whom we have a growing number—want to understand and to use the family language. As Jews-by-choice, they have the same claim to the words as do Jews-by-birth.

In this particular lexicon, I hope to introduce adult beginners to some frequently used Jewish value terms and, in the process of defining these terms, I hope to enlarge the Hebrew vocabularies of adult students who want more out of their Hebrew language studies than a smattering of modern tourist phrases. *Your Jewish Lexicon* attempts to encourage this enlargement by building clusters or families of certain Hebrew words that are related to some of the key terms in the text. One of the very congenial idiosyncrasies of Hebrew is that many words are based upon a three-letter *shoresh*, root (two-letter and four-letter roots are far less common). The three letters are consonants; by adding vowel signs and sometimes more consonants, we derive additional words whose meanings are often connected in some way to that of the original root. To cite an example of a word discussed above, *aliyah*: the Hebrew verb meaning to "go up, rise up, ascend" is *alah*, spelled *ayin-lamed-hei*; from *alah*, we can construct a sizable cluster of words ranging from *oleh*, a male immigrant to Israel, to *ma'alit*, an elevator—all of them based on the same Hebrew root letters and all of them expressing in some way the idea of "going up, ascending." We do somewhat the same thing with certain English words by adding or subtracting prefixes and suffixes—e.g., command, commandment, commander, commanding.

Many Jews are unaware that they know some Hebrew, even though they cannot read it or do not know the alphabet. (The very word "alphabet" yields two Hebrew words, *alef* and *bet*, the first two letters of the Hebrew alphabet.) Whenever possible, I start with a word or a term you probably have heard—either in Hebrew or Yiddish—and, by building on it, I go from the known directly to the unknown.

II

Your Jewish Lexicon originated as a series of sixty-four short articles published by the Department of Adult Jewish Studies of the Union of American Hebrew Congre-

gations. They proved so popular that I have rearranged and revised them, adding new articles (there are now seventy-two) and—most importantly—presenting the key words and phrases not only in English transliteration but also in Hebrew, complete with vowel signs. The seventy-two short chapters by no means exhaust the list of our intramural words and phrases—there are many more. For this book, I have selected terms that are frequently used, offering an opportunity for demonstrating related Hebrew words and phrases.

Wherever possible, I cite biblical passages which use significant Hebrew words so that you will see the words in context and experience the excitement of recognizing a word or phrase from the Hebrew Bible. Whenever space permits, I refer you to passages in the new series of Hebrew-English prayer books published by the Central Conference of American Rabbis: *Shaarei Tefillah (Gates of Prayer): The New Union Prayerbook* for Weekdays, Sabbaths, and Festivals, with Services and Prayers for Synagogue and Home; *Shaarei Habayit (Gates of the House): The New Union Prayerbook*, with Prayers and Readings for Home and Synagogue; *Shaarei Teshuvah (Gates of Repentance): The New Union Prayerbook for the Days of Awe*; and *Shaarei Mitzvah (Gates of Mitzvah): A Guide to the Jewish Life Cycle*. A fifth volume, *Shaarei Binah (Gates of Understanding)*, a companion volume to *Shaarei Tefillah*, offers a number of interesting essays on the subject of prayer in the Reform movement.

I also refer you to *The Torah: A Modern Commentary*, by Rabbis W. Gunther Plaut and Bernard J. Bamberger, published by the Union of American Hebrew Congregations.

The biblical translations used here by permission of The Jewish Publication Society of America are drawn from the authoritative English translations of the Hebrew Bible published by the Society: *The Holy Scriptures*; *The Torah: The Five Books of Moses*; *The Book of Psalms*; *The Five Megilloth and the Book of Jonah*; and *The Prophets: Nevi'im*.

To delve more deeply into our vocabulary, I recommend the very learned and readable volume, *A Book of Jewish Concepts*, by Philip Birnbaum, Hebrew Publishing Company, New York, 1962. For more on Jewish life and lore, you will want to consult *The Jewish Encyclopedia* or the more recent *Encyclopaedia Judaica*.

The *New Bantam-Megiddo Hebrew and English Dictionary*, by Dr. Reuven Sivan and R. Edward Levenston, Bantam Books (paperback), New York, 1975, will be helpful with modern Hebrew words but not, as I have explained earlier, with older traditional terms or phrases. Lovers of Yiddish will find it a pleasure to browse through the *Modern English-Yiddish, Yiddish-English Dictionary*, by Uriel Weinreich, Schocken Books (paperback), New York, 1977.

I want to extend my warmest thanks to my colleagues, Rabbi Daniel B. Syme, national director, Department of Education, Union of American Hebrew Congregations, and Rabbi Steven M. Reuben, former associate director, both of whom served as first readers of the series of *Your Jewish Lexicon* articles and offered valuable suggestions and counsel. My special thanks go to Rabbi Bernard M. Zlotowitz of the Union for his careful review and scholarly emendations. I am indebted to the Union's copy editing department and specially to Annette Abramson for their painstaking efforts in checking this bilingual, sometimes trilingual, manuscript. I want finally to thank the many rabbis and laypersons who were kind enough to send their generous comments about the original series of *Lexicon* articles.

Edith Samuel
New York

Preface

For Your Information

I have divided the seventy-two articles in this book somewhat arbitrarily into five sections. Some articles can fall into two or more sections, but I have chosen to group them for easy flow and maximum readability. For easy reference, I have supplied a detailed table of contents as well as separate lists of contents at the beginning of each section.

For those beginning to learn Hebrew, there is a listing (see Appendix) of the name and pronunciation of each letter of the Hebrew alphabet and the sounds of the Hebrew vowel signs.

Those of you who wish to increase your Hebrew vocabularies will find the key Hebrew words as well as the core words or Hebrew roots drawn from the text and listed separately on the facing page. This arrangement will allow you to see the pronunciation, definitions, and related word-clusters at a glance.

Make sure that a copy of the *Tanach*, the Hebrew Bible, is always at hand so that you can refer to it and experience the satisfaction of being able to recognize significant words in the Hebrew text. Any other book mentioned in a chapter should also be at hand. To find additional biblical illustrations of particular Hebrew word usages, a good Hebrew-English Bible concordance will be useful. At the end of this lexicon there is a list of selected bibliography which should also prove helpful.

A number of familiar prayers or biblical passages quoted in this book have been set to music. One good source for the words and music is *Songs and Hymns*, a supplement to *Gates of Prayer*. Like all the *Gates of . . .* books, *Songs and Hymns* may be ordered from the Central Conference of American Rabbis, 21 East 40th Street, New York, N.Y. 10016.

In selecting English translations of Hebrew quotations from among the various versions produced by the Jewish Publication Society of America, I chose the translation that, in my view, best illustrated the Hebrew term under discussion, also the one that I felt was the most beautiful, moving, or familiar. More often than not, I have selected, over later versions, examples from the 1917 translation used in the JPS 1955 edition of *The Holy Scriptures*. Despite the unimpeachable scholarship that went into the preparation of the 1972 translation of *The Book of Psalms*, I still

prefer the magnificent English and marvelous cadences of that 1917 translation. A list of quotations used throughout, chapter by chapter, with the exact source of the quotation appears at the end of the lexicon. Readers are invited to look up the differing versions and to decide for themselves which they prefer.

My original intention was to present all the Hebrew spellings in this book in the *malei* (full) form used in modern Israel. However, this plan had to be discarded because much of the Hebrew in *Your Jewish Lexicon* is quoted from the Hebrew Bible and prayer book, both of which use the old *chaser* (lacking) form. The significant difference between the two is that the full form inserts the letters *vav* and *yod* when necessary while the lacking form often omits those letters and uses vowel signs instead. (As a rough analogy, modern American English drops the letter *u* in words like "honor" and "color" while British English uses the full form, "honour" and "colour." The pronunciation is, of course, not affected.) Occasionally, the reader may notice two different forms for the same word. Readers should be aware that many modern Hebrew dictionaries use the *malei* or full form as their preferred style, but either form is acceptable.

Yiddish words are transliterated according to the style presented in the *Modern English-Yiddish, Yiddish-English Dictionary*, by Uriel Weinreich, Schocken Books, 1977, while the Hebrew words are transliterated according to the style presented in the *Guide to Hebrew Transliteration According to Israeli Pronunciation*, edited by Werner Weinberg, Union of American Hebrew Congregations, 1977.

YOUR JEWISH LEXICON

Section One

The People
of the Books

1 In the Beginning

When Jews decide to increase their Jewish vocabulary, where do they begin? At the beginning, naturally, with the very first word of the first chapter of the first book of the Torah. That opening word is *bereshit* (pronounced be-ray-SHEET), and it is popularly understood to mean "in the beginning." Every Jew needs to know that word because, in addition to opening the Torah, *Bereshit* is also the Hebrew name of the first book of the Torah. Many people call it by its English title, Genesis, but Jews have become accustomed to using the Hebrew title, *Bereshit*.

Anyone who knows a bit of Hebrew can discover in the Hebrew core of *bereshit* the Hebrew letters that spell the noun, *rosh*, meaning "head, chief, leader, beginning." *Rosh Hashanah*, the Jewish New Year, is literally the "head" or the "beginning" of the *shanah*, year. *Rosh Chodesh* is the "beginning" of the *chodesh*, month.

Visitors to the modern State of Israel already know the adjective, *rishon*, first. Tourists flock to Rishon le-Tsiyon, a city which is famous for its wine cellars. Founded in 1882, it was the first settlement to be built by Jewish pioneers who came to the land from abroad—hence its name, "first in Zion." Visitors to Israel quickly discover the phrase, *yom rishon*, the first day or Sunday. Sunday, not Monday, is the *yom rishon* of the Jewish week. In Israel, the *yom rishon* is a normal workday.

For the Jew who wants to begin to learn about Judaism from the beginning, the best place to begin is with *bereshit*, in the beginning.

1 בְּרֵאשִׁית

Core word: רֹאשׁ

in the beginning	bereshit בְּרֵאשִׁית
beginning of the Torah, Book of Genesis	Bereshit בְּרֵאשִׁית
the Five Books of Moses	Torah תּוֹרָה
head, chief, leader, beginning	rosh רֹאשׁ
year	shanah שָׁנָה
month	chodesh חֹדֶשׁ
Jewish New Year	Rosh Hashanah רֹאשׁ הַשָּׁנָה
beginning of the month	Rosh Chodesh רֹאשׁ חֹדֶשׁ
first in Zion	Rishon le-Tsiyon רִאשׁוֹן לְצִיּוֹן
the first day, Sunday	yom rishon יוֹם רִאשׁוֹן

2 Consider the *Siddur*

For many centuries the Jewish prayer book has been called the *siddur*. Why? Because the consonants in the word—*samech-dalet-resh*, equivalent to the English *s-d-r*—form the Hebrew word meaning "set in order, arrange." What is the *siddur* but an arrangement of prayers in a certain order for the observance of Shabbat, holidays, and weekdays?

The core Hebrew letters are familiar to every Jew in connection with *Pesach*, Passover. The *seder* is the *order* of the family home service on the eve of that festival. The order of the service appears in the book known as the *Haggadah shel Pesach*, literally the "telling" of the Passover story.

Each Shabbat, we read a set portion of the Torah. This is done in a definite, regular order, week after week in the Jewish *shanah*, year. The section of the week is called, simply enough, the *sidrah*.

On a trip to Israel, you will hear an expression used by everyone and soon you will get into the habit of using it yourself. The expression is *ha-kol be-seder*, everything's in order. In English we say "OK" and we mean just about the same thing. A more emphatic expression is *be-seder gamur*, meaning "in complete, absolute, perfect order." We've come a long way from *siddur, seder,* and *sidrah*, but it is fascinating to see how an ancient language can accommodate modern idioms.

2 סִדּוּר

Hebrew root: ‫ס-ד-ר‬

Jewish prayer book	siddur סִדּוּר
the order of the family home service on Passover eve	seder סֵדֶר
Sabbath	Shabbat שַׁבָּת
Passover	Pesach פֶּסַח
the book telling the Passover story	הַגָּדָה שֶׁל פֶּסַח Haggadah shel Pesach
set portion of the Torah read every week	sidrah סִדְרָה
everything's in order	ha-kol be-seder הַכֹּל בְּסֵדֶר
in complete, absolute, perfect order	be-seder gamur בְּסֵדֶר גָּמוּר

3 The People of the Book

For over a thousand years, the Jewish people has been called the *am ha-Sefer*, the people of the Book. The phrase was applied to the Jews by the Moslems in the seventh century. The *sefer*, book, referred to is, of course, the *Sefer ha-Sefarim*, the Book of Books, our Hebrew Bible, which is not *one* book but a collection of twenty-four (or thirty-nine, depending upon how you count) *sefarim*.

Nearly every Jew knows the word, *sefer*, from the phrase *bet sefer*, a school, schoolhouse for children, or from *Sefer Torah*, the precious handwritten parchment scroll containing the Five Books of Moses. The *Sefer Torah* is our most sacred Jewish possession. The ark of every synagogue holds one or more scrolls.

The *Sefer Torah* is painstakingly produced by hand by a scribe, a *sofer*. In Jewish tradition, the Torah scribe is a pious and skilled professional who goes about his holy task according to ancient and very strict rules. He may not, for example, set down the text from memory; he must consult a perfect model for every word and letter, even though he may know the passages by heart. He must use a feather quill (nowadays, generally the quill of a turkey feather) that has been especially sharpened for the work.

In the Bible, the Book of Ezra is named for Ezra *ha-Sofer*, Ezra the Scribe (he was also a priest), who was a leader in guiding the people in rebuilding the Temple in Jerusalem after the return of the Jewish exiles from Babylonian captivity in approximately the fifth century B.C.E. In modern Hebrew, the term *sofer* still designates a professional scribe, and it has been extended to mean also an author or literary man. The feminine form is *soferet*.

Since we are the *am ha-Sefer*, it is no accident that we value Jewish learning, respect *sefarim*, and encourage a Jewish *sifriyah*, library, in every Jewish home. Our attitude toward our sacred *sefarim* is reverential. A worn-out or damaged *siddur*, for instance, is never discarded. In the Jewish tradition, either we deposit the fragments and the worn *sefarim* in a *genizah*, a storage room or hiding place, or we give them a Jewish burial.

3 עַם הַסֵּפֶר

Hebrew root: ס-פ-ר

people	עַם *am*
book	סֵפֶר *sefer*
the people of the Book	עַם הַסֵּפֶר *am ha-Sefer*
books	סְפָרִים *sefarim*
the Book of Books, the Hebrew Bible	סֵפֶר הַסְּפָרִים *Sefer ha-Sefarim*
school, schoolhouse	בֵּית סֵפֶר *bet sefer*
handwritten parchment scroll containing the Five Books of Moses	סֵפֶר תּוֹרָה *Sefer Torah*
Torah scribe	סוֹפֵר *sofer*
author, literary person	סוֹפֵר *sofer* (masc.)
	סוֹפֶרֶת *soferet* (fem.)
library	סִפְרִיָּה *sifriyah*
storage room or hiding place for worn-out sacred books	גְּנִיזָה *genizah*

4 Introducing the *Tanach*

While we Jews are the *am ha-Sefer*, the people of the Book, many modern Jews don't know the correct title of our Book. The "Bible," the "Hebrew Bible," or the "Holy Scriptures" will all do, but the proper name for Jews to use is the *Tanach*.

Where does that name originate? It is formed from the initial letters of the three sections of our *Sefer ha-Sefarim*, Book of Books. The *tav* or letter *T* stands for the *Torah*, the first section. The *nun* or *N* stands for *Nevi'im*, the Prophets, whose books comprise the second section. The *CH* at the end, a form of the Hebrew letter *chaf*, stands for *Ketuvim*, the Writings, the third and last section of the Hebrew Bible. Put the consonants together and you get *TaNaCH*, our name for the Hebrew Bible. When writing in Hebrew, a quotation mark between the second and third Hebrew letters shows us that the word is an abbreviation.

We never call the *Tanach* the "Old Testament." That is a Christian term having implications that are unacceptable to Jews. The term suggests: (1) that the "new" has supplanted the "old," an idea which Jews reject; (2) that the "old" is no longer valid, a proposition to which Jews cannot subscribe; and (3) that the "old" and the "new" are equally sanctified, an idea Jews have denied for 2,000 years.

As the *am ha-Sefer*, all Jews should learn the name of our glorious *sefer: Tanach*. It should be remembered that the *Tanach* is the collection of twenty-four (or thirty-nine, depending upon how you count) sacred Hebrew *sefarim* by which Jews have lived—and for which countless Jews have died—over the centuries. Learn it and teach it to your children: *TANACH!*

4 תַּנַ"ךְ

Core words: תּוֹרָה, נְבִיאִים, כְּתוּבִים

the Hebrew Bible, an abbreviation
formed from the initial letters of the
three sections of the Hebrew Bible

Tanach תַּנַ"ךְ

the Five Books of Moses, the first
section of the Hebrew Bible

Torah תּוֹרָה

the Hebrew Prophets whose books
form the second section of the
Hebrew Bible

Nevi'im נְבִיאִים

the Writings, the books in the third
section of the Hebrew Bible

Ketuvim כְּתוּבִים

5 The First Five

The Hebrew word, *torah*, has various levels of meaning. It can be defined as moral and religious "instruction, teaching." It can refer to *all* of Jewish learning found not only in the *Tanach* but also in the Talmud and other sacred Jewish literature. It is sometimes translated as "Law"—a misnomer according to some Jewish scholars, who observe that "Law" is manifestly too narrow a term. Finally, *the Torah* (note the definite article) can be used to denote very specifically the first section of the *Tanach*. In this sense, *the Torah* means the Five Books of Moses or the *Pentateuch* (*penta* is "five" in Greek). The *Torah* is also called the *Chumash*, a name derived from the Hebrew word for "five."

The English names of these five *sefarim* are generally descriptive of their contents. *Genesis*, meaning "origin," tells the story of the Creation and relates the history of the patriarchs. *Exodus* is the "going out" from Egypt. *Leviticus* is a compilation of laws relating to the Levites, the priests who were members of the tribe of Levi. *Numbers* refers to the census of the Israelites in the wilderness. *Deuteronomy* is the "repetition, the second telling," of the Mosaic laws. (*Deutero* is Greek for "second.") Using mnemonics to help you remember the proper order of these books, you'd get GELeND.

The Hebrew titles of these same *sefarim* are not necessarily descriptive of their contents but, rather, are taken from the opening word or phrase of each Hebrew book. Genesis is *Bereshit* (see chapter 1) from its first word which means "in the beginning." Exodus is called *Shemot*, names, from the opening phrase, "*ve-eleh shemot*, these are the *names*." Leviticus is *Vayikra* from the opening word which means "and the Lord *called.* . . ." Numbers is *Bemidbar* which means "in the wilderness." Deuteronomy is *Devarim*, words, from the initial phrase, "*eleh ha-devarim asher diber Mosheh*, these are the *words* which Moses spoke." A mnemonic for the names of the books is tricky but manageable: *BeSh-Va-BeD*. Try it!

5 תּוֹרָה, חֻמָשׁ

Core words: תּוֹרָה, חֻמָשׁ

moral and religious instruction, teaching	torah	תּוֹרָה
the Five Books of Moses, the Pentateuch	Torah	תּוֹרָה
the Five Books of Moses	Chumash	חֻמָשׁ
Genesis	Bereshit	בְּרֵאשִׁית
Exodus	Shemot	שְׁמוֹת
Leviticus	Vayikra	וַיִּקְרָא
Numbers	Bemidbar	בְּמִדְבַּר
Deuteronomy	Devarim	דְּבָרִים

6 The Prophets, Part I

Every Jewish child in religious school grows up knowing the song, *Eliyahu ha-Navi*. *Eliyahu* is, of course, the prophet Elijah, one of the extraordinary company of God-appointed men and women who placed their unique stamp upon Judaism and the world. Their searing words are as applicable to society today as they were to their own societies of Judah and Israel during the millennium before the Common Era. We call these men and women collectively, *nevi'im*, prophets, and the books both about them and by them make up the second section of the *Tanach*.

The term *navi* (the feminine is *neviah*) means "one who speaks in behalf of or for God." The *nevi'im* were called upon to transmit the word of God to the people. No matter the depth of their reluctance, they were compelled to speak out. Jonah tried to run away; Moses, the greatest of the prophets (although we refer to him as "our teacher" rather than as "our prophet") shrank from the call to lead the Israelites out of Egypt; and Jeremiah lamented that he had ever been born because "everyone curses me" (Jeremiah 15:10).

Theirs was a life of loneliness and enormous personal anguish. They were charged with reminding the people, who preferred not to listen, of what God required of them. The wealthy and ruling classes were infuriated by the prophets' unremitting attack upon the social injustice, the idolatry, and the moral decline in the Jewish kingdoms. The prophets were given the task of denouncing evil and evildoers, of announcing punishment unless the people repented, and then of comforting the people in their agony of catastrophe and exile. Bearers of God's word, the prophets were also intercessors for the people, trying to avert impending calamity. After the shocking episode in the desert when the Israelites fell to worshiping the golden calf, God was so enraged that He was ready to destroy them. Only the intercession of Moses saved the people from extinction (Exodus 32:7-14).

6 נְבִיאִים

Core words: נָבִיא, נְבִיאִים

"Elijah the Prophet"	*Eliyahu ha-Navi* אֵלִיָּהוּ הַנָּבִיא
prophet	*navi* נָבִיא
prophets	*nevi'im* נְבִיאִים
prophetess	*neviah* נְבִיאָה
prophetesses	*neviot* נְבִיאוֹת
the Prophets, the second section of the Hebrew Bible	*Nevi'im* נְבִיאִים

7 The Prophets, Part II

In the Jewish tradition, the *nevi'im* are generally classified into two categories: the *Nevi'im Rishonim*, the First or Former Prophets and the *Nevi'im Acharonim*, the Later or Latter Prophets.

The *Nevi'im Rishonim* include men like Samuel, who installed the first two Jewish kings, Saul and David (David reigned from about 1005 to 965 B.C.E.); Nathan, who bitterly denounced King David for his seduction of Bathsheba; Elijah, who confronted the wicked King Ahab and Queen Jezebel; and Elijah's disciple, Elisha, who is best remembered as a miracle worker. The activities of these early prophets are recorded in the biblical books of Samuel and Kings.

By contrast, the *Nevi'im Acharonim* were literary men—that is, they (or their scribes) wrote their own texts or edited and collated their own speeches and utterances. These have come down to us in the books bearing their names. The Later Prophets are further divided into two categories: Major and Minor. These descriptions have nothing to do with the relative merits of the prophets; rather, they refer to the length of their books . The books of Isaiah, Jeremiah, and Ezekiel are substantially large—hence they are the Major Prophets. The so-called Minor Prophets—there were twelve and they are known in an Aramaic phrase as the *Terei Asar*, The Twelve—left us only a few chapters or fragments. In the Jewish tradition, the works of the *Terei Asar* are counted as one biblical book.

Amos and Hosea were the first of the *Nevi'im Acharonim*. They suddenly appeared a few decades before the fall of the northern Kingdom of Israel in 722 B.C.E. Prophecy, *nevuah*, disappeared from the scene about a century after the destruction of Jerusalem in 587-586 B.C.E. The *Nevi'im Acharonim* lived in times of enormous upheaval and change, somewhat reminiscent of our own twentieth century. Three world empires rose successively: Assyria, Babylonia, and Persia. Buffeted by the ruthless and warring world powers, the tiny kingdoms of Israel and Judah were torn apart by the polarization between the small wealthy class and the masses of the poor. No wonder the burning words of the Later Prophets sound so pertinent to the modern world.

7 נְבִיאִים

Core words: נָבִיא, נְבִיאִים

the First or Former Prophets	*Nevi'im Rishonim* נְבִיאִים רִאשׁוֹנִים
the Later or Latter Prophets	*Nevi'im Acharonim* נְבִיאִים אַחֲרוֹנִים
The Twelve [Prophets]	*Terei Asar* (Aramaic) תְּרֵי עֲשַׂר
prophecy	*nevuah* נְבוּאָה

8 The Written Word

More and more, young Jewish couples about to be married are commissioning illuminated *ketubot*, marriage contracts. (The singular form is *ketubah*.) They engage artists and calligraphers to design and write the traditional Hebrew-Aramaic legal Jewish document that sets forth the groom's financial obligations to his bride even in the event of death or divorce. The purpose of the *ketubah* has always been to protect the woman against easy divorce. The *ketubah*, duly signed by the groom and witnesses, is read out by the rabbi or cantor as part of the traditional Jewish marriage ceremony. Examples of brilliantly colored and decorated *ketubot*, ancient and modern, are found in Jewish art collections and are reproduced in standard books of Jewish art.

At the core of the word, *ketubah*, are the Hebrew letters *kaf-tav-bet*. (In some cases, *bet* changes to *vet* and the *kaf* to *chaf*.) The meaning of this Hebrew root always signifies something related to writing. The Hebrew verb meaning to "write" is *katav*; "writing" is *ketivah*; "letter" is a *michtav*; the "address" on the outside of the envelope is the *ketovet*; and, in modern Hebrew, a typewriter is a *mechonat ketivah*, a machine for writing.

We call the Holy Writ or Scriptures *Kitvei ha-Kodesh*, literally, "holy writings." The third section of our *Tanach, Ketuvim*, the Writings or the Hagiographa (from the Greek, "sacred writings") includes such masterpieces of religious expression and literary genius as the Psalms, Proverbs, Job, and the *Chamesh Megillot* (Five Scrolls).

On the High Holy Days, we think of ourselves as passing before the Heavenly Throne where we must account for our actions of the previous year, and we plead to be inscribed in the *Sefer Chayim*, the Book of Life, for a good year ahead. The familiar Jewish greeting during the Days of Awe is: *Leshanah tovah tikatevu*, May you be inscribed [written down] for a good year.

8 כְּתוּבִים

Hebrew root: כ-ת-ב

marriage contract	כְּתֻבָּה *ketubah*
marriage contracts	כְּתֻבּוֹת *ketubot*
write	כָּתַב *katav*
writing	כְּתִיבָה *ketivah*
letter	מִכְתָּב *michtav*
address on an envelope	כְּתֹבֶת *ketovet*
typewriter	מְכוֹנַת כְּתִיבָה *mechonat ketivah*
the Holy Writ, Scriptures	כִּתְבֵי הַקֹּדֶשׁ *Kitvei ha-Kodesh*
the Writings, Hagiographa	כְּתוּבִים *Ketuvim*
the Five Scrolls	חָמֵשׁ מְגִלּוֹת *Chamesh Megillot*
the Book of Life	סֵפֶר חַיִּים *Sefer Chayim*
May you be inscribed [written down] for a good year.	לְשָׁנָה טוֹבָה תִּכָּתֵבוּ. *Leshanah tovah tikatevu.*

9 Round and Round

The Hebrew word *megillah* has entered the American language (and English-language dictionaries) as a somewhat comical and disparaging slang term. For example: "I ask him for a straight yes-no answer, but he gives me a whole *megillah*"—in short, a tediously long drawn out tale. Actually, *megillah* (plural, *megillot*) simply means a "scroll" or a "roll"; it does not indicate "long." In ancient times, books were handwritten on continuous strips of parchment and were rolled up when not in use. The famous Dead Sea Scrolls [*megillot*] were so fragile after 1,900-odd years of storage that they had to be unrolled with meticulous care.

Jews use the term *megillah* for five comparatively short books of the *Tanach*: *Shir ha-Shirim*, The Song of Songs, read during synagogue services on the Sabbath of Passover; *Megillat Ruth*, the Scroll or Book of Ruth, read on Shavuot; *Echah*, Lamentations, read on Tishah be-Av; *Kohelet* or Ecclesiastes, read on the Sabbath of Sukot; and *Megillat Esther*, the Scroll or Book of Esther, read on Purim. These five scrolls are included in the *Ketuvim*, the third and final section of the *Tanach*.

The Hebrew verb meaning to "roll, roll up, roll away" is *galal*. A close relative of *galal* is *gilgel*, to roll, revolve. In Hebrew, a "wheel, cycle" is a *galgal*, an ordinary roller skate is *galgilit*. The Kabbalists used an esoteric, mystical term, *gilgul*, to mean the transmigration of the soul at death into another body. (The technical term is "metempsychosis," but in modern, colloquial speech we could explain the concept as "recycling" of the soul.) Anyone who has seen the famous Yiddish play (later translated into Hebrew) by S. An-Ski called *The Dybbuk* will recall that the soul of the dead hero entered the body of the young bride, with horrifying and tragic results.

9 מְגִלָּה

Core words: גָּלַל, גִּלְגֵּל

scroll	מְגִלָּה *megillah*
scrolls	מְגִלּוֹת *megillot*
The Song of Songs	שִׁיר הַשִּׁירִים *Shir ha-Shirim*
the Scroll or Book of Ruth	מְגִלַּת רוּת *Megillat Ruth*
Lamentations	אֵיכָה *Echah*
Ecclesiastes	קֹהֶלֶת *Kohelet*
the Scroll or Book of Esther	מְגִלַּת אֶסְתֵּר *Megillat Esther*
roll, roll up, roll away	גָּלַל *galal*
roll, revolve	גִּלְגֵּל *gilgel*
wheel, cycle	גַּלְגַּל *galgal*
roller skate	גַּלְגִּלִית *galgilit*
metempsychosis, the transmigration or "recycling" of the soul	גִּלְגוּל *gilgul*

10 The *Tanach:* The Twenty-four (or Thirty-nine) Books in Their Traditional Order

I. THE TORAH	I. *TORAH*	תּוֹרָה
(Pentateuch,	(*Chumash*)	(חֻמָשׁ)
Five Books of Moses)		
(1) Genesis	(1) *Bereshit*	בְּרֵאשִׁית
(2) Exodus	(2) *Shemot*	שְׁמוֹת
(3) Leviticus	(3) *Vayikra*	וַיִּקְרָא
(4) Numbers	(4) *Bemidbar*	בְּמִדְבַּר
(5) Deuteronomy	(5) *Devarim*	דְּבָרִים
II. THE PROPHETS	II. *NEVI'IM*	נְבִיאִים
The First Prophets	Nevi'im Rishonim	נְבִיאִים רִאשׁוֹנִים
(6) Joshua	(6) *Yehoshua*	יְהוֹשֻׁעַ
(7) Judges	(7) *Shofetim*	שׁוֹפְטִים
(8) I Samuel	(8) { *Shemuel Alef*	שְׁמוּאֵל א'
(9) II Samuel	{ *Shemuel Bet*	שְׁמוּאֵל ב'
(10) I Kings	(9) { *Melachim Alef*	מְלָכִים א'
(11) II Kings	{ *Melachim Bet*	מְלָכִים ב'
The Later Prophets	Nevi'im Acharonim	נְבִיאִים אַחֲרוֹנִים
The Major Prophets		
(12) Isaiah	(10) *Yeshayah*	* יְשַׁעְיָה
(13) Jeremiah	(11) *Yiremeyah*	* יִרְמְיָה
(14) Ezekiel	(12) *Yechezkel*	יְחֶזְקֵאל

* The traditional rendering omits the vav. The proper readings, however, are *Yeshayahu* and *Yiremeyahu*.

The Minor Prophets (The Twelve)	Terei Asar	תְּרֵי עָשָׂר
(15) Hosea	Hoshea	הוֹשֵׁעַ
(16) Joel	Yoel	יוֹאֵל
(17) Amos	Amos	עָמוֹס
(18) Obadiah	Ovadyah	עֹבַדְיָה
(19) Jonah	Yonah	יוֹנָה
(20) Micah	Michah	מִיכָה
(21) Nahum	(13) Nachum	נַחוּם
(22) Habakkuk	Chavakuk	חֲבַקּוּק
(23) Zephaniah	Tsefanyah	צְפַנְיָה
(24) Haggai	Chagai	חַגַּי
(25) Zechariah	Zecharyah	זְכַרְיָה
(26) Malachi	Malachi	מַלְאָכִי

III. THE HOLY WRITINGS (Hagiographa)	III. KETUVIM	כְּתוּבִים
(27) Psalms	(14) Tehilim	תְּהִלִּים
(28) Proverbs	(15) Mishlei	מִשְׁלֵי
(29) Job	(16) Iyov	אִיּוֹב

The Five Scrolls	Chamesh Megillot	חָמֵשׁ מְגִלּוֹת
(30) The Song of Songs	(17) Shir ha-Shirim	שִׁיר הַשִּׁירִים
(31) Ruth	(18) Ruth	רוּת
(32) Lamentations	(19) Echah	אֵיכָה
(33) Ecclesiastes	(20) Kohelet	קֹהֶלֶת
(34) Esther	(21) Esther	אֶסְתֵּר
(35) Daniel	(22) Daniel	דָּנִיֵּאל
(36) Ezra	(23) Ezra	עֶזְרָא
(37) Nehemiah	Nechemyah	נְחֶמְיָה
(38) I Chronicles	(24) Divrei ha-Yamim Alef	דִּבְרֵי הַיָּמִים א׳
(39) II Chronicles	Divrei ha-Yamim Bet	דִּבְרֵי הַיָּמִים ב׳

Section Two

Some Values
That Jews Cherish

11 *Shalom*, Part I

A poet once insisted that the loveliest phrase in the English language was "cellar door." Obviously, the poet valued sound over meaning. If we Jews were asked to name the most beautiful word in our Jewish lexicon, we would undoubtedly rank meaning over sound because we cherish the allusions, aspirations, and emotions intimately associated with certain Hebrew words. One such word is *shalom*, which, in everyday usage, can mean either "hello" or "goodbye."

The traditional greeting among Jews is *shalom aleichem*, peace unto you, to which the response is *aleichem shalom*, to you, peace. But today, on the streets of Tel Aviv, we are far more likely to hear one Israeli greeting another with *Shalom! Mah shelomcha?* (addressed to a male; to a female, it is *Mah shelomech?*). The English equivalent is "Hello! How are you?" Literally, the phrase means "What is [the state of] your peace?"

Shalom has a host of meanings; some denote external circumstances, others internal feelings or state of mind. Packed into *shalom* are both objective and subjective concepts like wholeness, peace, security, tranquility, completeness, contentment, safety, and well-being. Merely to stop fighting or to suspend strife is not *shalom* as Jews understand it. The Psalmist bids us: *Bakesh shalom*, Seek peace (34:15). Dynamic, positive, and restorative action is required. Thus, when the State of Israel seeks *shalom* with all her neighbors, she does not mean a cease-fire but a constructive peace for all the peoples in the Middle East. When we say *Shabbat shalom* to family and friends after a draining workweek, we mean far more than "have a peaceful and restful day." What we are really saying is: May you be restored to wholeness on the blessed Sabbath!

שָׁלוֹם 11

Core word: שָׁלוֹם

hello, goodbye	שָׁלוֹם *shalom*
peace unto you	שָׁלוֹם עֲלֵיכֶם *shalom aleichem*
to you, peace	עֲלֵיכֶם שָׁלוֹם *aleichem shalom*
How are you? (addressed to a male)	מַה שְׁלוֹמְךָ? *Mah shelomcha?*
How are you? (addressed to a female)	מַה שְׁלוֹמֵךְ? *Mah shelomech?*
wholeness, peace, security, tranquility, completeness, contentment, safety, well-being	שָׁלוֹם *shalom*
seek peace	בַּקֵּשׁ שָׁלוֹם *bakesh shalom*
Sabbath peace	שַׁבָּת שָׁלוֹם *Shabbat shalom*

12 More about *Shalom,* Part II

The word *shalom* is not only one of the most radiant in the Jewish lexicon but it is also one of the most frequently used. Peace runs like a golden thread throughout our dreams and prayers. On pages 100-101 and 692-695 of the new Union prayer book, *Gates of Prayer,* you will find a number of fervent and familiar petitions for the blessing of *shalom.* We pray for peace to descend upon us and upon all the world. On a personal level, within our own families, we strive for *shelom bayit,* peace in the home, a goal of domestic tranquility attained through kindness, consideration, and respect for all members of the family.

Shalom, Sholom, and *Shelomoh* (the feminine form is *Shelomit*) are common Hebrew names. King Solomon's name in the Hebrew Bible is *Shelomoh ha-Melech.*

A great many congregations in North America incorporate *shalom* into their names, either alone, as in Temple Shalom, or in combination with other Hebrew words. Among the familiar temple names are *Berit Shalom,* which means a covenant of peace (in modern Hebrew, the phrase is used for a "peace pact"); *Rodef Shalom,* meaning "pursuer of peace"; *Sha'arei Shalom,* which translates as "gates of peace"; and *Bet Shalom,* which means "house of peace."

Scholars debate the origins of the name, Jerusalem, *Yerushalayim;* but, in Jewish tradition, the poetic explanation is that it is the *Ir Shalom,* the City of Peace. Since the days of King David, Jerusalem has been the unique center of Jewish hopes and longings. Jewish poets and composers have poured out their love for the city in psalms, prayers, threnodies, poems, and songs. We remember Jerusalem always in our prayers. You will find one of the most beautiful and moving of these, *Shelom Yerushalayim,* the "Peace of Jerusalem," in *Gates of Prayer,* page 65: And turn in compassion to Jerusalem, Your city. Let there be peace in her gates, quietness in the hearts of her inhabitants.

שָׁלוֹם 12

Core word: שָׁלוֹם

peace	שָׁלוֹם *shalom*
peace in the home	שְׁלוֹם בַּיִת *shelom bayit*
King Solomon	שְׁלמֹה הַמֶּלֶךְ *Shelomoh ha-Melech*
covenant of peace, a peace pact	בְּרִית שָׁלוֹם *berit shalom*
pursuer of peace	רוֹדֵף שָׁלוֹם *rodef shalom*
gates of peace	שַׁעֲרֵי שָׁלוֹם *sha'arei shalom*
house of peace	בֵּית שָׁלוֹם *bet shalom*
Jerusalem	יְרוּשָׁלַיִם *Yerushalayim*
City of Peace	עִיר שָׁלוֹם *Ir Shalom*
"Peace of Jerusalem"	שְׁלוֹם יְרוּשָׁלַיִם *Shelom Yerushalayim*

13 Justice—Not Charity

We Jews do not give charity. Rather, we perform an act of justice or righteousness, and the word for it in the Jewish lexicon is *tsedakah*. In the Jewish tradition, the poor and the unfortunate (like widows, orphans, and the stranger in our midst) have the right—the *legal right* under Jewish law—to food, clothing, and shelter. It is the obligation of every Jew to give *tsedakah*—to perform an act of justice by giving help—not out of momentary whim or sudden philanthropic impulse but out of religious *duty*. President John F. Kennedy once said, "Life is sometimes unfair." It certainly is. Indeed, precisely because life *is* unfair, the Jewish Sages of 2,000 years ago made the giving of *tsedakah* obligatory, even for a person receiving *tsedakah*, if only a penny or a crust of bread.

Tsedakah is connected with other Hebrew words based on the Hebrew root letters, *tsadei-dalet-kof*, equivalent to the English letters *ts-d-k*. *Tsedek* means "righteousness, justice," a word so powerful that it appears twice in the famous quotation, *Tsedek, tsedek tirdof*, Justice, justice shall you pursue (Deuteronomy 16:20). The *tsadik* is a "just, righteous person"; the feminine form is *tsadeket*; and the plural is *tsadikim*. Among Chasidim, the *tsadik* is a great and saintly leader. According to Jewish legend, there are thirty-six secret righteous persons in every generation who sustain the world, *lamed-vav tsadikim*.

Tsedakah is never a handout. It is the right thing for a Jew to do because *tsedek*, justice, demands it.

13 צְדָקָה

Hebrew root: ק-ד-צ

act of justice, righteousness	*tsedakah* צְדָקָה
righteousness, justice	*tsedek* צֶדֶק
justice, justice shall you pursue	צֶדֶק, צֶדֶק תִּרְדֹּף *tsedek, tsedek tirdof*
just, righteous man	*tsadik* צַדִּיק
just, righteous woman	*tsadeket* צַדֶּקֶת
chasidic leader	*tsadik* צַדִּיק
the thirty-six secret righteous persons in the world	*lamed-vav tsadikim* ל"ו צַדִּיקִים

14 Expressions of Love

Those who seek to denigrate Jews and Judaism charge that ours is a harsh and wrathful religion, dictated by a stern and unyielding Deity. The charge is both false and malicious, as anyone can discover from the frequent appearance of *ahavah*, love, not only in our *Tanach*, but also in our *siddur* and other sacred books. How stern can our Lord be when He commands us: *Ve-ahavta le-re'acha kamocha*, Love your neighbor as yourself (Leviticus 19:18)? How harsh and wrathful can a religion be that repeatedly insists upon telling us: *Va-ahavtem et ha-ger*, Love the stranger (for just one example, see Deuteronomy 10:19)?

Two ancient and beautiful prayers, *Ahavah Rabbah*, "Great Love," and *Ahavat Olam*, "Everlasting Love," precede the recitation of the *Shema*, the Jewish watchword and declaration of God's unity that is found in Deuteronomy 6:4 and in every Jewish prayer book. (In *Gates of Prayer*, "Great Love" appears on page 302 and "Everlasting Love" is on page 130.) Immediately after the *Shema*, we recite the passage from Deuteronomy 6:5: You shall love the Lord your God with all your heart and with all your soul and with all your might. This supreme teaching, called *ahavat ha-Shem*, love for God, is complemented by other basic Jewish teachings such as God's love for the world, and God's love for the Jewish people. Even the salient obligations of Judaism are expressed in terms of love: *ahavat Torah*, love for Torah; *ahavat limud*, love of learning; *ahavat Yisrael*, love for the Jewish people; and *ahavat Erets Yisrael*, love for the Land of Israel. A lover of peace is an *ohev shalom*.

These are only a small sampling of the frequency of *ahavah*—love—in Jewish teachings. It is an indispensable word in every Jewish lexicon.

14 אַהֲבָה

Hebrew root: א-ה-ב

love	אַהֲבָה *ahavah*
Love your neighbor as yourself.	וְאָהַבְתָּ לְרֵעֲךָ כָּמוֹךָ.
	Ve-ahavta le-re'acha kamocha.
Love the stranger.	וַאֲהַבְתֶּם אֵת הַגֵּר. *Va-ahavtem et ha-ger.*
"Great Love"	אַהֲבָה רַבָּה *Ahavah Rabbah*
"Everlasting Love"	אַהֲבַת עוֹלָם *Ahavat Olam*
the Jewish watchword and declaration of God's unity, "hear"	שְׁמַע *Shema*
You shall love the Lord your God with all your heart. . . .	וְאָהַבְתָּ אֵת יְהֹוָה אֱלֹהֶיךָ בְּכָל לְבָבְךָ. . . .
	Ve-ahavta et Adonai Elohecha be-chol levavcha. . . .
love for God	אַהֲבַת הַשֵּׁם *ahavat ha-Shem*
God's love for the world	אַהֲבַת הַשֵּׁם לָעוֹלָם
	ahavat ha-Shem la-olam
love for Torah	אַהֲבַת תּוֹרָה *ahavat Torah*
love of learning	אַהֲבַת לִמּוּד *ahavat limud*
love for the Jewish people	אַהֲבַת יִשְׂרָאֵל *ahavat Yisrael*
love for the Land of Israel	אַהֲבַת אֶרֶץ יִשְׂרָאֵל *ahavat Erets Yisrael*
lover of peace	אוֹהֵב שָׁלוֹם *ohev shalom*

15 Loving-kindness

One of the high-frequency words in the Jewish lexicon is *chesed*, which means "kindness, love, goodness, benevolence, affection"—all rolled into one. Perhaps the best translation is the old-fashioned but still luminous English word, "loving-kindness."

On the foundations of *chesed*, the Rabbis built the concept of *gemilut chasadim*, literally, "the bestowal of loving-kindness," or "acts, deeds of loving-kindness." These are personal acts of human sympathy, performed totally unselfishly, wholly out of goodness, and without ulterior motive. In practicing *gemilut chasadim*, we neither seek nor expect thanks or reciprocation. Among the acts regarded as *gemilut chasadim* are honoring one's parents, restoring peace between disputants, visiting the sick, burying the dead, comforting mourners, and generally helping others—all in a spirit of good will and good cheer.

The Rabbis regarded acts of loving-kindness as among those things "which have no fixed measure"—that is, there is no ceiling on *gemilut chasadim*. Nor is there any ceiling on the number or variety of sympathetic actions human beings can extend to one another. Loving-kindness can be bestowed by anyone, young or old, rich or poor.

Old Tobit, the endearing hero of the Book of Tobit (a book that appeared in the Greek translation of our Bible but was omitted from the Hebrew Bible canon), is forever getting into trouble because of his insistence upon burying the Jewish dead. Tobit, a pious and upright man of the tribe of Naftali, lived in exile in Nineveh. In carrying out his exemplary *gemilut chasadim*, Tobit risked his own life by defying Assyrian decrees against burial of the Jewish dead. The Book of Tobit tells a heartwarming and charming story. It is a pity that the Sages did not include it among the sacred Jewish books in the *Tanach*.

15 חֶסֶד

Hebrew root: ח-ס-ד

kindness, love, goodness, benevolence,
affections, loving-kindness

chesed חֶסֶד

acts, deeds of loving-kindness

gemilut chasadim גְּמִילוּת חֲסָדִים

16 Remembering

We are a people with a long history and an equally long *zikaron*, memory. The importance of remembering is stressed over and over again in our Torah, our prayers, and our rituals. A number of critical words in our Jewish lexicon are built on the base of the Hebrew letters *z-k-r* (*zayin-kaf-resh*) or *z-ch-r* (*zayin-chaf-resh*). Many Jews know some of these "remembering" words from frequent repetition.

The Friday night *Kiddush*, for example, tells us that the Shabbat is a *zikaron le-ma'aseh vereshit*, a reminder of the work of creation, and also a *zecher li-tsiat Mitsrayim*, a remembrance of the Exodus from Egypt. The Fourth Commandment bids us: *Zachor et yom ha-Shabbat le-kadesho*, Remember the Sabbath day, to keep it holy (Exodus 20:8). The Torah keeps reminding us (e.g., Deuteronomy 5:15): *Ve-zacharta ki eved hayita be-erets Mitsrayim*, Remember that you were a slave in the land of Egypt. . . . To be a Jew means to remember always who and what we were—and are.

Proverb 10:7 gives us the phrase, *zecher tsadik livrachah*, the memory of the righteous shall be for a blessing. The abbreviation *z"l*, after a name, means *zichrono livrachah*, his memory is for a blessing, or *zichronah livrachah*, her memory is for a blessing. The *Yizkor* prayer (literally, "May He remember") is recited on Yom Kippur and on the festivals. (The text of the prayer is in *Gates of Prayer*, page 551.)

In modern Hebrew, a secretary is a *mazkir* (male) or a *mazkirah* (female). How is a secretary connected with remembering? Exodus 17:14 gives the clue.

16 זָכַר

Hebrew root: ז-כ-ר, ז-כ-ר

memory	זִכָּרוֹן *zikaron*
reminder of the work of creation	זִכָּרוֹן לְמַעֲשֵׂה בְרֵאשִׁית *zikaron le-ma'aseh vereshit*
remembrance of the Exodus from Egypt	זֵכֶר לִיצִיאַת מִצְרַיִם *zecher li-tsiat Mitsrayim*
Remember the Sabbath day, to keep it holy.	זָכוֹר אֶת יוֹם הַשַּׁבָּת לְקַדְּשׁוֹ. *Zachor et yom ha-Shabbat le-kadesho.*
Remember that you were a slave in the land of Egypt.	וְזָכַרְתָּ כִּי עֶבֶד הָיִיתָ בְּאֶרֶץ מִצְרָיִם. *Ve-zacharta ki eved hayita be-erets Mitsrayim.*
The memory of the righteous shall be for a blessing.	זֵכֶר צַדִּיק לִבְרָכָה. *Zecher tsadik livrachah.*
his memory for a blessing	(abbrev.) *z"l* ז״ל
his memory for a blessing	*zichrono livrachah* זִכְרוֹנוֹ לִבְרָכָה
her memory for a blessing	(abbrev.) *z"l* ז״ל
her memory for a blessing	*zichronah livrachah* זִכְרוֹנָה לִבְרָכָה
"May He Remember"	*Yizkor* יִזְכֹּר
secretary	*mazkir* (masc.) מַזְכִּיר *mazkirah* (fem.) מַזְכִּירָה

17 Compassion

In every generation, Jews have been taught to demonstrate *rachamanut*, pity, mercy, compassion. In Yiddish the word is *rakhmones*. We have been urged to become worthy of being called *rachamanim benei rachamanim*, compassionate children of compassionate forebears. Why this emphasis on the quality of mercy?

The answer is found in the deliberations of the talmudic Rabbis who subjected every word, every letter, every dot in the *Tanach* to intense scrutiny. Exodus 34:6 tells us that God is *rachum ve-chanun*, compassionate and gracious. From this passage, the Rabbis derived the significant teaching: Just as God is called compassionate and gracious, so you must be compassionate and gracious. Compassion is one of His attributes; we must therefore strive to emulate God. As human beings, we can never attain to God's perfection; nevertheless, we must continue to try. In terms of human conduct, this has always meant that we must act compassionately towards all human beings and, indeed, all living creatures.

The word *rachamim*, which like *rachamanut* means "mercy, pity, compassion," is deeply imbedded in the memories of all those who have ever attended a Jewish funeral service. Perhaps the most searing moment at such services comes when the cantor rises to chant the traditional *El Malei Rachamim*, "O God Full of Compassion." (The text appears in *Gates of the House*, page 185.)

At the root of all the "compassion" words are the three Hebrew letters, *resh-chet-mem*. The letters spell the verb, *richem*, to pity, show mercy to. Interestingly enough, the same three letters spell *rechem*, womb. This has led to endless conjecture on the possible connection between "compassion" and "womb." Is compassion born in the womb? Are women predisposed to act compassionately? How would you explain it?

17 רַחֲמָנוּת

Hebrew root: ר-ח-ם

pity, mercy, compassion	רַחֲמָנוּת *rachamanut*
	רַחֲמִים *rachamim*
compassionate children of compassionate forebears	רַחֲמָנִים בְּנֵי רַחֲמָנִים *rachamanim benei rachamanim*
compassionate and gracious	רַחוּם וְחַנּוּן *rachum ve-chanun*
"O God Full of Compassion"	אֵל מָלֵא רַחֲמִים *El Malei Rachamim*
pity, show mercy to	רִחֵם *richem*
womb	רֶחֶם *rechem*

18 Pity for the Living

One of the most touching expressions in the Jewish lexicon is *tsa'ar ba-alei chayim*, literally, "pain of living things." In the Jewish view, animals are just as much creatures of God as is humankind; and humankind has the responsibility, not only of respecting their needs and their *feelings*, but also of treating them with *rachamanut*. Animals suffer *tsa'ar*, pain, sorrow, and Jews are therefore prohibited from inflicting pain upon them. The familiar Yiddish word, *tsores*, is simply the Hebrew word *tsarah*, trouble, misfortune, in its plural form, *tsarot*.

The Torah shows exquisite sensitivity to the feelings of animals—a sensitivity rare in the ancient world. On the Sabbath, domestic animals as well as human beings must rest (Exodus 20:10; Deuteronomy 5:14). Deuteronomy 25:4 prohibits the muzzling of an ox while it is threshing (it may want to eat). An animal may not be slaughtered on the same day as its young (Leviticus 22:28). Before the days of the tractor, farmers were forbidden to plow with an ox and an ass yoked together (the ox, being larger, might cause pain to its smaller partner). Deuteronomy 22 spells out additional injunctions for Jews living an agrarian life: If you see an ox or an ass collapsed on the road under its burden, you must help it get on its feet; if you find a stray sheep or ox, you must return it to its owner or, if the owner is unknown, you must care for it until the owner claims it.

The Rabbis of the Talmud and of later generations went even further: Jews were enjoined never to sit down to eat before their animals had been fed; they were prohibited from buying an animal unless they could afford to feed it; and hunting for sheer sport is brutally cruel and hence forbidden to Jews. Slaughtering animals for food must be done as quickly and as painlessly as possible to avoid unnecessary or prolonged torment for the animal. In modern Hebrew, *tsa'ar ba-alei chayim* is translated as the "prevention of cruelty to animals."

18 צַעַר בַּעֲלֵי חַיִּים

Core words: צַעַר, צָרָה

pain of living things	צַעַר בַּעֲלֵי חַיִּים *tsa'ar ba-alei chayim*
pain, sorrow	צַעַר *tsa'ar*
trouble, misfortune	צָרָה *tsarah*
troubles, misfortunes	צָרוֹת *tsarot*
prevention of cruelty to animals	צַעַר בַּעֲלֵי חַיִּים *tsa'ar ba-alei chayim*

19 The Seal of Truth

A lovely *midrash*, commentary, points out a lesson in the Hebrew spelling of the word *emet*, truth. Its first letter, *alef*, opens the Hebrew alphabet; its middle letter, *mem*, is the middle letter of the alphabet; and its final letter, *tav*, is the final letter of the Hebrew alphabet. Hence, said the Rabbis, *emet* is the beginning, the middle, and the end of all things.

The Sages of the Talmud considered the concept of *emet* so important that they called it the "seal of God." Indeed, when setting forth the attributes of God, Exodus 34:6 states that He is *rav chesed ve-emet*, abundant in goodness and truth. The Rabbis saw *emet*, truth, as one leg of the tripod that sustains the world, the other two being *din*, justice, and *shalom*, peace. Between nations, as between people, truth must prevail lest the whole world collapse into chaos. And individuals who engage in self-deception, persistently lying to themselves, can very often bring about the collapse of their private worlds.

The prophet Zechariah, speaking the word of the Lord, proclaimed to the people (8:16-17): Speak the truth (*Dabru emet*) to one another, render true and perfect justice in your gates. And do not contrive evil against one another, and do not love perjury, because all those are things that I hate.

Any Jew who has ever mourned a relative or friend knows the words *emet* from the benediction, *Baruch Dayan ha-emet*, Blessed is the Judge of truth or the "righteous Judge." It expresses the Jew's submission to God's will at the moment of deepest sorrow.

19 אֱמֶת

Core word: אֱמֶת

truth	אֱמֶת *emet*
the first letter of *emet* and the first letter of the Hebrew alphabet	א *alef*
the middle letter of *emet* and the middle letter of the Hebrew alphabet	מ *mem*
the final letter of *emet* and the final letter of the Hebrew alphabet	ת *tav*
abundant in goodness and truth	רַב חֶסֶד וֶאֱמֶת *rav chesed ve-emet*
Speak the truth.	דַּבְּרוּ אֱמֶת. *Dabru emet.*
Blessed is the Judge of truth, the "righteous Judge."	בָּרוּךְ דַּיָּן הָאֱמֶת. *Baruch Dayan ha-emet.*

20 To Do Justice

The beautiful passage in Micah 6:8 that defines what the Lord requires of us begins: *Ki im asot mishpat*, Only to do justice. Justice, *mishpat*, is a rich and critical word in the Jewish lexicon.

At the heart of *mishpat* are the three Hebrew letters, *shin-pei-tet* (at times the *pei* becomes *fei*), corresponding to the English sh-p-t or sh-f-t. This root gives us a number of important words and ideas. The verb, *shafat*, means to "judge, decide, pass judgment, sit as a magistrate." Moses spent a great deal of his time sitting *lishpot et ha-am*, to judge the people (Exodus 18:13). When Jethro, his father-in-law, noticed how Moses was wearing himself out (Exodus 18) acting as the sole magistrate, Jethro advised him to appoint able men, *anshei emet*, men of truth, honest men, who could judge in routine matters. Moses did so: *Ve-shaftu et ha-am be-chol et*, And they [the magistrates] judged the people at all seasons (Exodus 18:26), thus freeing Moses for his larger labors.

A judge is a *shofet* (plural, *shofetim*). For a time in our history, our leaders were *shofetim*. One book in our *Tanach*, entitled *Shofetim*, Judges, describes the chaotic period that lasted from the death of Joshua until just before the prophet Samuel, approximately 1220-1050 B.C.E. Conditions were anarchic; the people were rebellious. From time to time, the Lord would raise up *shofetim* to save the people, but, when the *shofet* died, the people would return to anarchy. Later, during Samuel's lifetime, the people clamored: *Tenah lanu melech le-shoftenu*, Give us a king to judge us (I Samuel 8:6).

Some of the loveliest language in sacred Hebrew literature is associated with the word *mishpat* which means, among other things, "judgment, justice, right, cause, suit, decision, sentence" ("sentence" in both law and grammar). *Dirshu mishpat*, Seek justice (Isaiah 1:17), is a watchword. In *Gates of Prayer*, pages 685-688, there are eloquent examples of *mishpat*.

20 מִשְׁפָּט

Hebrew root: שׁ-פ-ט, שׁ-פ-ט

only to do justice	כִּי אִם עֲשׂוֹת מִשְׁפָּט *ki im asot mishpat*
judgment, justice, right, cause, suit, decision, sentence	מִשְׁפָּט *mishpat*
judge, decide, pass judgment, sit as a magistrate	שָׁפַט *shafat*
to judge the people	לִשְׁפֹּט אֶת הָעָם *lishpot et ha-am*
men of truth, honest men	אַנְשֵׁי אֱמֶת *anshei emet*
a judge	שׁוֹפֵט *shofet*
Book of Judges	שֹׁפְטִים *Shofetim*
Give us a king to judge us.	תְּנָה לָנוּ מֶלֶךְ לְשָׁפְטֵנוּ. *Tenah lanu melech le-shoftenu.*
Seek justice.	דִּרְשׁוּ מִשְׁפָּט. *Dirshu mishpat.*

21 Eternal Hope

The *Tanach* presents a true-to-life portrait of the people in our Book, depicting flaws as well as virtues, sorrows as well as joys; at no point are human failings or feelings of fear or doubt glossed over. Job, who endured heartbreaking calamities, confessed to despair: My days . . . are spent *be-efes tikvah*, without hope (Job 7:6). Zophar, one of his friends, tried to comfort him: And you shall be secure *ki yesh tikvah*, because there is hope (Job 11:18). The prophet Jeremiah, trying to relieve the terrible suffering of the Jews sent into captivity, relayed God's promise: And they shall come back from the land of the enemy. *Ve-yesh tikvah*, And there is hope, for your future, says the Lord (Jeremiah 31:16-17).

Hope, *tikvah*, belongs in every Jewish lexicon—and heart. When things have looked darkest, we have always tried to say with the Psalmist: O my God, rescue me out of the hand of the wicked. . . . *Ki Atah tikvati*, For You are my hope (Psalms 71:4-5).

We don't know what went on in the mind of the Hebrew poet, Naphtali Herz Imber (1856-1909), when he wrote the song *Tikvatenu*, "Our Hope," later changed to *Ha-Tikvah*, "The Hope," but the fortunes of the Jewish people at the time (1884) were at a low ebb, with pogroms and persecution in Eastern Europe, and with the early Jewish pioneers struggling against disease, poverty, and intractable soil to establish agricultural settlements in the Land of Israel. He could not have foreseen that *Ha-Tikvah* would become the national anthem of the Zionist movement and then of the new Jewish state. What exactly was the hope he articulated?

> Yet our hope is not lost, *Od lo avdah tikvatenu,*
> that hope of two millennia, *ha-tikvah shenot alpayim,*
> to be a free people in our land, *li-heyot am chofshi be-artsenu,*
> the land of Zion and Jerusalem. *be-erets Tsiyon vi-rushalayim.*

Imber projected *ha-tikvah*, and, four decades after his death, *ha-tikvah* had become reality.

21 הַתִּקְוָה

Core word: תִּקְוָה

hope (noun)	תִּקְוָה *tikvah*
without hope	בְּאֶפֶס תִּקְוָה *be-efes tikvah*
because there is hope	כִּי יֵשׁ תִּקְוָה *ki yesh tikvah*
and there is hope	וְיֵשׁ תִּקְוָה *ve-yesh tikvah*
for You are my hope	כִּי אַתָּה תִּקְוָתִי *ki Atah tikvati*
our hope	תִּקְוָתֵנוּ *tikvatenu*
"The Hope"	הַתִּקְוָה *Ha-Tikvah*
yet our hope is not lost	עוֹד לֹא אָבְדָה תִקְוָתֵנוּ *od lo avdah tikvatenu*
that hope of two millennia	הַתִּקְוָה שְׁנוֹת אַלְפַּיִם *ha-tikvah shenot alpayim*
to be a free people in our land	לִהְיוֹת עַם חָפְשִׁי בְּאַרְצֵנוּ *li-heyot am chofshi be-artsenu*
the land of Zion and Jerusalem	בְּאֶרֶץ צִיּוֹן וִירוּשָׁלַיִם *be-erets Tsiyon vi-rushalayim*

22 Dedication and Education

A close connection exists between Chanukah and Jewish education. Both words are built on the same Hebrew root letters, *chet-nun-kaf*, that spell the verbs *chanach*, to "dedicate, consecrate, train, train up," and *chinech*, "dedicate, inaugurate, educate, train." The noun *chinuch* means "inauguration, dedication, consecration, training, education, upbringing." Chanukah is the Festival of Dedication, marking the rededication of the Temple in Jerusalem in the year 165 B.C.E., when the Maccabees were victorious over their Greek-Syrian oppressors. When Jewish parents enroll their children in religious school for *chinuch*, they are literally carrying out the counsel of Proverb 22:6: *Chanoch la-na'ar*, Train up a child in the way he should go, / And even when he is old, he will not depart from it.

Various forms of the Hebrew verb and noun meaning "dedicate" or "dedication" appear in our *Tanach*. The dedication of the altar, *chanukat ha-mizbe'ach*, in the wilderness is described in Numbers 7. King Solomon and all the children of Israel dedicated the house of the Lord in Jerusalem (the First Temple) with splendid ceremonies (I Kings 8:63). When the Children of Israel returned from the Babylonian captivity and rebuilt the Temple, they held a great *chanukat bet Elaha*, dedication of the house of the Lord (Ezra 6:16). And, as we learn in Nehemiah 12:27, when the returned captives built the walls of Jerusalem (about 440 B.C.E.), they arranged a joyous *chanukah*, dedication, of the city walls.

Jewish homes as well as sacred buildings were dedicated. We learn this from an extraordinary passage beginning with Deuteronomy 20:5 that specifies the various circumstances under which an Israelite could be exempted from army service. Before a battle, officers had to ask their troops: What man is there that has built a new house and *lo chanacho*, has not dedicated it? Let him go and return to his house, lest he die in the battle and another man dedicate it.

To this day, we observe a custom called *chanukat ha-bayit*, dedication of a [new] house, during which we affix a *mezuzah* to the doorpost. The consecration service appears in *Gates of the House*, page 105.

22 חֲנֻכָּה

Hebrew root: ח-נ-כ, ח-נ-ך

dedicate, consecrate, train, train up	*chanach* חָנַךְ
dedicate, inaugurate, educate, train	*chinech* חִנֵּךְ
inauguration, dedication, consecration, training, education, upbringing	*chinuch* חִנּוּךְ
Festival of Dedication	*Chanukah* חֲנֻכָּה
Train up a child.	*Chanoch la-na'ar.* חֲנֹךְ לַנַּעַר.
dedication of the altar	*chanukat ha-mizbe'ach* חֲנֻכַּת הַמִּזְבֵּחַ
dedication to the house of the Lord	חֲנֻכַּת בֵּית אֱלָהָא *chanukat bet Elaha*
he has not dedicated it	*lo chanacho* לֹא חֲנָכוֹ
dedication of a [new] house	*chanukat ha-bayit* חֲנֻכַּת הַבַּיִת

23 In Whom Shall We Trust?

Many of us know the homey Yiddish word, *bitokhn*, trust, security, confidence. Actually, Yiddish borrowed the word from Hebrew. The meaning remains the same, but, in Hebrew, the word is pronounced *bitachon*. From *bitachon*, we get *betach*, which in both Hebrew and Yiddish can be a noun, "security, safety," and also an adverb, "certainly, surely."

The Hebrew verb, *batach*, based on the three-letter root, *bet-tet-chet*, means "lean on, trust, be confident." At times, the *bet* changes to a *vet*.

Psalm 146:3 warns: *Al tivtechu vi-nedivim be-ven adam*, Put not your trust in princes nor in the son of man [human beings]. The sense is to be wary of trusting the mighty or the mortal; they die, and with them are apt to die also their promises and their power. In whom, then, shall we trust? Psalm 37:3 tells us: *Betach badonai va-aseh tov*, Trust in the Lord, and do good. Psalm 125:1-2 gives us a striking poetic image: *Ha-botechim badonai ke-Har Tsiyon*, Those who trust in the Lord are like Mount Zion, that cannot be moved, enduring forever. Jerusalem, hills enfold it, and the Lord enfolds His people now and forever.

Modern Israel, like ancient Israel, is greatly concerned with her *bitachon*, security, safety, and thus invests enormous energies and equipment in her defenses. The Minister of Defense in Israel is called the *Sar ha-Bitachon*, literally, the "Minister of Security."

בִּטָחוֹן 23

Hebrew root: ב־ט־ח, ב־ט־ח

trust, security, confidence	bitachon בִּטָחוֹן
security, safety	betach בֶּטַח
certainly, surely	betach בֶּטַח
lean on, trust, be confident	batach בָּטַח

Put not your trust in princes nor in the son of man [human beings]
אַל תִּבְטְחוּ בִנְדִיבִים בְּבֶן אָדָם.
Al tivtechu vi-nedivim be-ven adam.

Trust in the Lord, and do good.
בְּטַח בַּיהֹוָה וַעֲשֵׂה טוֹב
Betach badonai va-aseh tov.

Those who trust in the Lord are like Mount Zion.
הַבֹּטְחִים בַּיהֹוָה כְּהַר צִיּוֹן.
Ha-botechim badonai ke-Har Tsiyon.

[Israeli] Minister of Defense [Minister of Security]
Sar ha-Bitachon שַׂר הַבִּטָחוֹן

24 Wisdom, Knowledge, and Understanding, Part I

A few years ago, a fish company launched an advertising campaign featuring a herring *mevin* (rhymes with "cave-in"). A *mevin* is an "expert, connoisseur, judge," and the word—generally used with amusement—seems to have entered the American language. *Mevin*, in fact, is a serious Hebrew word (it is also used in Yiddish) that has as its core the three Hebrew letters, *bet-yod-nun*. (The *bet* often changes to *vet*.) The basic root, *bin*, means to "understand, discern." From *bin* we can build a vocabulary of significant Hebrew words. Among them are the verbs, *hevin* or *havin*, understand, discern; the adjective, *navon*, understanding, discerning; and the nouns, *mevin*, expert, *binah*, understanding, and *mevinut*, expertise, knowledgeability.

Pirkei Avot 3:21 reminds us: *Im en da'at, en binah*, Without knowledge, there is no understanding; *im en binah, en da'at*, without understanding, there is no knowledge. Nehemiah 8:2 recounts how the priest Ezra brought the Torah before the men and women of the congregation "and all that could hear with understanding, *ve-chol mevin lishmoa*." One of the companion volumes to *Shaarei Tefillah, Gates of Prayer*, is called *Shaarei Binah, Gates of Understanding*. A prayer for *binah* appears in *Gates of Prayer*, page 39.

I Kings 3:5-14 records a remarkable incident in which God appears to King Solomon in a dream one night and asks what gift He can give him. Solomon wisely requests "an understanding heart" so that he may be able to discern, *le-havin*, between good and evil when he judges the people. God tells him: *Natati lecha lev chacham ve-navon*, I have given you a wise and an understanding heart. Indeed, God is so pleased that Solomon asks nothing for himself that He gives him a bonus: in addition to the *lev chacham ve-navon*, God gives him both riches and honor. And, while we are speaking of *navon*, we should note that the current president of the State of Israel, a discerning and cultivated man, bears the appropriate name, Yitzchak Navon.

24 בִּינָה

Hebrew root: בּ-י-ן, ב-י-ן

expert, connoisseur, judge	מֵבִין *mevin*
understand, discern	הֵבִין *hevin*
	הָבִין *havin*
understanding, discerning (adj.)	נָבוֹן *navon*
understanding (noun)	בִּינָה *binah*
expertise, knowledgeability	מְבִינוּת *mevinut*

Without knowledge, there is no understanding;
without understanding, there is no knowledge.

אִם אֵין דַּעַת, אֵין בִּינָה;
אִם אֵין בִּינָה, אֵין דַּעַת.
Im en da'at, en binah;
im en binah, en da'at.

and all that could hear with understanding

וְכֹל מֵבִין לִשְׁמֹעַ
ve-chol mevin lishmoa

Gates of Understanding

שַׁעֲרֵי בִּינָה *Shaarei Binah*

I have given you a wise and an understanding heart.

נָתַתִּי לְךָ לֵב חָכָם וְנָבוֹן.
Natati lecha lev chacham ve-navon.

a wise and an understanding heart

לֵב חָכָם וְנָבוֹן
lev chacham ve-navon

53

25 Wisdom, Knowledge, and Understanding, Part II

The first son in the *Haggadah shel Pesach* is called *chacham*, wise. The talmudic *chacham*, sage, Ben Zoma asked: *Ezehu chacham?* Who are wise? He answered: *Ha-lomed mi-kol adam*, Those who learn from all people [human beings] (*Pirkei Avot* 4:1). Possibly the first son acquired his store of *chochmah*, wisdom, from *kol adam* and especially from the *chachamim*, the Sages.

The Hebrew noun *chochmah*, wisdom (feminine, singular), is often yoked with two other critical nouns, *binah*, understanding, and *da'at*, knowledge. Isaiah speaks (11:2) of *ruach chochmah u-vinah*, the spirit of wisdom and understanding, and also of *ruach da'at ve-yirat Adonai*, the spirit of knowledge and of the fear [awe] of the Lord. Job 28:12 asks: *Ha-chochmah, me-ayin timatsei? Ve-ei zeh mekom binah?* Wisdom, where shall it be found? And where is the place [the location] of understanding?

The attainment of *chochmah* is such an imperative in Jewish thought that we have a body of literature specifically called the "wisdom books." Among them are Proverbs, Job, and Kohelet (Ecclesiastes). The words, *chacham* and *chochmah*, are especially frequent in Proverbs, where *chochmot* (feminine, plural) is personified as a woman: *Chochmot*, wisdom, cries aloud in the street (Proverbs 1:20)—wisdom is not locked up in some ivory tower but is easily available to all who seek it. We learn from Proverb 4:7: *Reshit chochmah: keneh chochmah*, The beginning of wisdom is: Get wisdom. The famous *eshet chayil*, woman of valor, in Proverb 31 has wisdom among her many virtues: *Pihah patchah ve-chochmah*, She opens her mouth with wisdom [she speaks wisely].

Possibly the loveliest usage of *chochmah* occurs in Psalm 90:12: So teach us to number our days, that we may get us *levav chochmah*, a heart of wisdom.

25 חָכְמָה

Core words: חָכְמָה, חָכָם

wise, sage (adj.)	chacham חָכָם
wise man, sage (noun)	chacham חָכָם
Who are wise? Those who learn from all people [human beings].	אֵיזֶהוּ חָכָם? הַלּוֹמֵד מִכָּל אָדָם. *Ezehu chacham?* *Ha-lomed mi-kol adam.*
the Sages, generally used to mean the Rabbis of the Talmud	chachamim חֲכָמִים
wisdom	chochmah (sing.) חָכְמָה chochmot (pl.) חָכְמוֹת
the spirit of wisdom and understanding	רוּחַ חָכְמָה וּבִינָה *ru'ach chochmah u-vinah*
the spirit of knowledge and of the fear [awe] of the Lord	רוּחַ דַּעַת וְיִרְאַת יְהֹוָה *ru'ach da'at ve-yirat Adonai*
Wisdom, where shall it be found? And where is the place [the location] of understanding?	הַחָכְמָה מֵאַיִן תִּמָּצֵא? וְאֵי זֶה מְקוֹם בִּינָה? *Ha-chochmah, me-ayin timatsei?* *Ve-ei zeh mekom binah?*
The beginning of wisdom is: Get wisdom.	רֵאשִׁית חָכְמָה: קְנֵה חָכְמָה. *Reshit chochmah: keneh chochmah.*
woman of valor	eshet chayil אֵשֶׁת חַיִל
She opens her mouth with wisdom.	פִּיהָ פָּתְחָה בְחָכְמָה. *Pihah patchah ve-chochmah.*
a heart of wisdom	levav chochmah לְבַב חָכְמָה

26 Wisdom, Knowledge, and Understanding, Part III

Along with *chochmah* and *binah*, the Jewish tradition places heavy importance on the value of *da'at*, knowledge. Speaking through the prophet Hosea, the Lord castigates His people "*ki en emet ve-en chesed ve-en da'at Elohim ba-arets*, because there is no truth, nor mercy, nor knowledge of God in the land" (Hosea 4:1). A few verses later (4:6), God rebukes His people for their lack of knowledge, *beli da'at*, of Him. The Lord uses the same phrase, *beli da'at*, without knowledge, when He speaks to Job and his comforters in Job 38:1-2: Then the Lord answered Job out of the whirlwind, and said, "Who is this that darkens counsel by words (*beli da'at*) without knowledge?" [i.e., confuses the situation by speaking out of ignorance]. Perhaps the best-known use of *da'at* occurs in Genesis 2:17. The first two human beings are warned not to eat of the *ets ha-da'at tov va-ra*, the tree of the knowledge of good and evil. Of course, they disobey.

The noun *da'at* comes from the Hebrew verb, *yada*, spelled *yod-dalet-ayin*, which means to "know, comprehend, perceive." At the opening of Exodus, we learn that "there arose a new king over Egypt who *lo yad et Yosef*, knew not Joseph." In Exodus 23:9, we are taught: You shall not oppress a stranger, for *atem yedatem et nefesh ha-ger*, you know the feelings [soul] of the stranger, having yourselves been strangers in the land of Egypt. After the death of Moses, there is an extraordinary tribute to him in Deuteronomy 34:10: And there has not arisen a prophet since in Israel like Moses, *asher yeda'o Adonai panim el panim*, whom the Lord knew face to face.

The verb *yada* is used in the Bible also to mean "know" in the sexual sense. As one example, look at Genesis 4:1: *Ve-ha-adam yada et Chavah ishto*, And the man knew Eve his wife; and she conceived and bore Cain. . . .

Yodea, the present tense of *yada*, is familiar from the Passover song, *Echad Mi Yodea?* "Who Knows One?" and also from the *Haggadah shel Pesach*. The fourth son is the "one who does not know how to ask, *echad she'eno yodea lishol*."

26 דַעַת

Hebrew root: ע-ד-י

knowledge	דַעַת *da'at*
because there is no truth, nor mercy, nor knowledge of God in the land	כִּי אֵין אֱמֶת וְאֵין חֶסֶד וְאֵין דַעַת אֱלֹהִים בָּאָרֶץ *ki en emet ve-en chesed ve-en da'at Elohim ba-arets*
without knowledge	בְּלִי דַעַת *beli da'at*
tree of the knowledge of good and evil	עֵץ הַדַעַת טוֹב וָרָע *ets ha-da'at tov va-ra*
know, comprehend, perceive	יָדַע *yada*
(he) knew not Joseph	לֹא יָדַע אֶת יוֹסֵף *lo yada et Yosef*
you know the feelings [soul] of the stranger	אַתֶּם יְדַעְתֶּם אֶת נֶפֶשׁ הַגֵּר *atem yedatem et nefesh ha-ger*
whom the Lord knew face to face	אֲשֶׁר יְדָעוֹ יְהֹוָה פָּנִים אֶל פָּנִים *asher yeda'o Adonai panim el panim*
and the man knew Eve his wife	וְהָאָדָם יָדַע אֶת חַוָּה אִשְׁתּוֹ *ve-ha-adam yada et Chavah ishto*
knows	יוֹדֵעַ *yodea*
"Who Knows One?"	אֶחָד מִי יוֹדֵעַ? *Echad Mi Yodea?*
the fourth son in the Haggadah, the one who does not know how to ask	אֶחָד שֶׁאֵינוֹ יוֹדֵעַ לִשְׁאוֹל *echad she'eno yodea lishol*

27 Proclaim Freedom

The Jewish lexicon has not one but three separate words for "freedom, liberty." The first is *deror*, the second, *cherut*, and the third, *chofesh*. The ringing passage from Leviticus 25:10 is traditionally translated as "proclaim liberty (*deror*) throughout the land." The prophet Isaiah proclaims *deror* to the captives (61:1). The prophet Jeremiah (34:8 ff.) uses both *deror* and variations of *chofesh* to chastise the people of Judah for failing to let their servants go free.

In the modern State of Israel, *Cherut*, freedom, liberty, is the name of the political party headed by Menachem Begin. In *Gates of Prayer*, page 41, there appears a prayer: "Sound the great horn to proclaim *cherutenu*, [our] freedom." The prayer continues: "Let *kol deror*, the song [voice] of liberty, be heard in the four corners of the earth." The Passover festival is known as the *zeman cherutenu*, the time [or season] of our freedom.

Chofesh, the noun meaning "freedom, liberty," and *chofshi*, the adjective meaning "free" (feminine, *chofshit*), appear frequently in the great chapters of Exodus 21 and Deuteronomy 15 that specify the circumstances under which Hebrew servants had to be freed in the sabbatical year. In addition, if a master maims a servant (see Exodus 21:26, 27), he must immediately send him out *la-chofshi*, to freedom.

We know the phrase *am chofshi* from the passage in the song *Ha-Tikvah*, "The Hope" (see chapter 21): *li-heyot am chofshi be-artsenu*, to be a free people in our land. Modern Hebrew has many phrases using *chofesh* or the adjectives *chofshi* and *chofshit*. Among them are: *bechirah chofshit*, free choice, free will; *chofesh ha-dibur*, the freedom of speech; and *chofesh ha-itonut*, freedom of the press. A "vacation" in modern Hebrew is *chofesh* or *chufshah*.

Core words: דְּרוֹר, חֵרוּת, חֹפֶשׁ

freedom, liberty	*deror* דְּרוֹר
	cherut חֵרוּת
	chofesh חֹפֶשׁ
our freedom	*cherutenu* חֵרוּתֵנוּ
song [voice] of liberty	*kol deror* קוֹל דְּרוֹר
time [or season] of our freedom	*zeman cherutenu* זְמַן חֵרוּתֵנוּ
free	*chofshi* (masc.) חָפְשִׁי
	chofshit (fem.) חָפְשִׁית
to freedom	*la-chofshi* לַחָפְשִׁי
free people	*am chofshi* עַם חָפְשִׁי
free choice, free will	*bechirah chofshit* בְּחִירָה חָפְשִׁית
freedom of speech	*chofesh ha-dibur* חֹפֶשׁ הַדִּבּוּר
freedom of the press	*chofesh ha-itonut* חֹפֶשׁ הָעִתּוֹנוּת
vacation	*chofesh* חֹפֶשׁ
	chufshah חֻפְשָׁה

28 The Meaning of Independence

The Hebrew phrase for Independence Day in Israel is *Yom ha-Atsma'ut*, literally, the "Day of Independence." *Etsem*, the three-letter root spelled *ayin-tsadei-mem*, means several things: "bone, substance, matter, essence," what we call in English the "core" of something or someone. Adam called Eve *etsem me-atsamai*, bone of my bones (Genesis 2:23). A "noun" in Hebrew is a *shem etsem*, literally, the "name itself"—the essence, the essential nature of the thing. The Hebrew word for "personal" is *atsmi*; and the Hebrew for "independent" is *atsma'i*.

Thus, *atsma'ut*, independence, evolves from *atsmi*—from one's own personal being, one's very bones. The old advertising slogan, "I'll do it myself, Mother!" was a declaration of *atsma'ut*, a determination to act without outside help.

Atsma'ut, independence (of persons or nations), means that individuals are able to be themselves. The American colonies in order to become the United States fought a revolution to sever ties with England and to achieve *atsma'ut*. Similarly, the State of Israel emerged in 1948 after a war for *atsma'ut*. Any person—or nation—to be able to stand up and announce to the world, "I am uniquely myself," must have the strength, the courage, and the backbone to maintain *atsma'ut*.

עַצְמָאוּת 28

Hebrew root: ע-צ-ם

[Israel] Day of Independence	*Yom ha-Atsma'ut* יוֹם הָעַצְמָאוּת
bone, substance, matter, essence	*etsem* עֶצֶם
bone of my bones	*etsem me-atsamai* עֶצֶם מֵעֲצָמַי
a noun	*shem etsem* שֵׁם עֶצֶם
personal	*atsmi* עַצְמִי
independent	*atsma'i* עַצְמָאִי
independence	*atsma'ut* עַצְמָאוּת

29 Honor and Respect

The Fifth Commandment enjoins us: *Kabed et avicha ve-et imecha,* Honor your father and your mother. The imperative verb here is *kabed,* a grave and serious word, never to be taken lightly. Building upon the core consonants, *kaf-bet-dalet,* *k-b-d* (sometimes the *kaf* becomes *chaf* and the *bet* changes to *vet*), we get a number of words that carry much weight in the Jewish lexicon.

The *k-b-d* root conveys the idea of to "honor, respect, or glorify" and also to "be weighty or heavy." The noun, *kavod,* means "honor, respect." The verb is *kibed.* Every Friday evening we light candles *lichvod Shabbat,* in honor of the Sabbath. During Passover, we drink special wine *lichvod Pesach,* in honor of Passover. We show respect and hospitality to guests by serving them *kibud,* refreshments.

One of the touching uses of the word comes in Exodus 4:10 when Moses is trying to explain to the Lord why he is unfit to lead the people—as though God needed to be told! Moses says: *Chevad peh u-chevad lashon anochi,* I am slow [heavy] of speech and slow [heavy] of tongue. Moses is saying, of course, that he stammers. The Lord quickly dismisses the argument by promising to help Moses.

The talmudic tract *Pirkei Avot, Sayings [Ethics] of the Fathers,* contains a telling observation (4:1): *Ezehu mechubad?* Who is honored [respected]? *Ha-mechabed et ha-beriyot,* One who honors [respects] all humankind.

But the person who pursues *kavod* out of vanity or self-aggrandizement had better be careful, for a Jewish Sage commented: *Kavod,* honor, flees from one who runs after it and follows one who flees from it.

Hebrew root: כ-ב-ד ,כּ-ב-ד

Honor your father and your mother.	כַּבֵּד אֶת אָבִיךָ וְאֶת אִמֶּךָ.
	Kabed et avicha ve-et imecha.
honor, respect (noun)	*kavod* כָּבוֹד
honor, respect (verb)	*kibed* כִּבֵּד
in honor of	*lichvod* לִכְבוֹד
refreshments [offered to a guest]	*kibud* כִּבּוּד
I am slow [heavy] of speech and slow [heavy] of tongue.	כְּבַד פֶּה וּכְבַד לָשׁוֹן אָנֹכִי.
	Chevad peh u-chevad lashon anochi.
Who is honored [respected]?	*Ezehu mechubad?* אֵיזֶהוּ מְכֻבָּד?
one who honors [respects all] humankind	הַמְכַבֵּד אֶת הַבְּרִיּוֹת
	ha-mechabed et ha-beriyot

30 Who Is a Hero?

Pirkei Avot (4:1) asks: *Ezehu gibor?* Who are strong? and answers: Those who control their passions. The question could also be translated from the Hebrew as "Who is a hero?" The Hebrew word, *gibor,* can be a noun meaning "hero, champion" and also an adjective meaning "strong, mighty, brave, valiant." The plural of both the noun and the adjective is *giborim.* A "heroine" is a *giborah* (plural, *giborot*). Building upon the three Hebrew letters of the root, *gimel-bet-resh* (sometimes *bet* becomes *vet*), equivalent in English to *g-b-r* or *g-v-r,* we get the verb *gavar,* to "be strong, be mighty, grow stronger." The noun, *gevurah,* means "strength, might, valor, heroism."

Perhaps the most moving elegy ever written was David's lament for Jonathan and Saul that appears in the opening chapter of II Samuel. The refrain that keeps echoing is *Ech naflu giborim!* How are the mighty fallen! David himself is called *ha-gever,* the man raised on high (II Samuel 23:1). It is curious that Boaz, the second husband of Ruth, whom we usually think of as a mild-mannered older man, should be called *ish gibor chayil,* a mighty man of valor (Ruth 2:1). The "woman of valor" in Proverbs 31:10 is the *eshet chayil* (see chapter 25).

During Chanukah, we give thanks, among other things, for *ha-gevurot,* the mighty deeds, by which our people was saved in the days of old. In the song, *Mi Yimalel* (*Gates of Prayer,* pages 757-758), we recall that "in every age a hero, *ha-gibor,* or sage came to our aid."

Both Yiddish and Hebrew use the word *gevir* to mean a "rich man, master or lord, man of substance." The female form, *geveret,* at one time meant a "mistress or lady" of an estate or royalty. In modern Hebrew, any woman—young, old, rich, poor—is addressed as *geveret,* the equivalent of the English Mrs., Miss, or Ms.

30 גִּבּוֹר

Hebrew root: ג-ב-ר, ג-ב-ר

Who are strong? Who is a hero?	*Ezehu gibor?*	אֵיזֶהוּ גִבּוֹר?
hero, champion	*gibor*	גִּבּוֹר
heroes, champions	*giborim*	גִּבּוֹרִים
strong, mighty, brave, valiant	*gibor*	גִּבּוֹר
	giborim (pl.)	גִּבּוֹרִים
heroine	*giborah*	גִּבּוֹרָה
heroines	*giborot*	גִּבּוֹרוֹת
be strong, be mighty, grow stronger	*gavar*	גָּבַר
strength, might, valor, heroism	*gevurah*	גְּבוּרָה
deeds of strength, might, valor, heroism	*gevurot*	גְּבוּרוֹת
How are the mighty fallen!	*Ech naflu giborim!*	אֵיךְ נָפְלוּ גִבּוֹרִים!
the man raised on high	*ha-gever*	הַגֶּבֶר
mighty man of valor	*ish gibor chayil*	אִישׁ גִּבּוֹר חַיִל
rich man, master or lord, man of substance	*gevir*	גְּבִיר
Mrs., Miss, Ms. (formerly mistress, lady)	*geveret*	גְּבֶרֶת

Section Three

Some Phrases of Daily Life

31. Have a Good Day!
 mazal tov, yom tov, Yom Kippur, Yom ha-Atsma'ut,
 Yom ha-Sho'ah, Yamim Nora'im, boker tov, erev tov,
 ki tov, tov me'od

32. Varieties of Houses
 bayit, bet, bet cholim, bet Yisrael, bet tefilah, bet midrash,
 bet knesset, ba'al bayit

33. Mothers and Fathers
 em, av, Sheloshah Avot, Arba Imahot, Avinu Malkenu,
 horim, morim

34. How Good and How Pleasant
 hineh mah tov u-mah na'im, achim, achayot

35. *Le-Chayim!*
 chayim, Shehecheyanu, chai

36. Happiness Is . . .
 same'ach, simchah, rinah, renanah, gil, chedvah, alizah, osher,
 ashrei, oneg Shabbat

37. To Your Health!
 bara, beriah, beriut, rofe, refuah, refael, bikur cholim

38. Let There Be Light!
 or, ma'or, ner, Ner Tamid, nerot, menorah, chanukiyah

31 Have a Good Day!

Two expressions in every Jewish vocabulary are *mazal tov*, good luck, congratulations, and *yom tov*, a holiday or, literally, a "good day." Now, consider how many more phrases you can build from just two short Hebrew words, *tov* and *yom*.

Everyone knows *Yom Kippur*, the Day of Atonement. American Jews are now familiar with *Yom ha-Atsma'ut*, Israel's Day of Independence. Prior to *Yom ha-Atzma'ut*, Jews the world over mark *Yom ha-Sho'ah*, the Day of the Holocaust. There is an equally solemn day, *Yom ha-Zikaron*, the Day of Remembrance, Memorial Day for those who fell while fighting for Israel's independence and security. The plural of *yom* is *yamim*. Every fall, we hear the phrase, *Yamim Nora'im*, the Days of Awe—that awesome ten-day penitential period between Rosh Hashanah and Yom Kippur.

Coming back to *tov*, good, you hear it dozens of times in Israel during the course of a single *yom*. "Good morning" is *boker tov;* "good evening" is *erev tov*. At night, when parting from friends, the phrase is *lailah tov*, good night. *Tov* by itself means "good! fine!"

Yom and *tov* are repeated again and again in the opening chapter of *Bereshit*. God created the light and saw how good, *ki tov*, it was. "And there was *erev* and there was *boker*, a first *yom*." The refrain, *ki tov*, keeps recurring through the *yamim* of Creation until on *yom ha-shishi*, the sixth day, after He had created humankind and surveyed all His work, God found everything *tov me'od*, very good. In *Bereshit*, chapter one, pick out the Hebrew words you now know: *tov*, *yom*, *boker*, *erev*, *ki tov*. It's like recognizing old friends!

Core words: טוֹב, יוֹם

good luck, congratulations	*mazal tov*	מַזָּל טוֹב
holiday, good day	*yom tov*	יוֹם טוֹב
Day of Atonement	*Yom Kippur*	יוֹם כִּפּוּר
[Israel] Day of Independence	*Yom ha-Atsma'ut*	יוֹם הָעַצְמָאוּת
Day of the Holocaust	*Yom ha-Sho'ah*	יוֹם הַשּׁוֹאָה
Day of Remembrance, Memorial Day	*Yom ha-Zikaron*	יוֹם הַזִּכָּרוֹן
day	*yom*	יוֹם
days	*yamim*	יָמִים
Days of Awe	*Yamim Nora'im*	יָמִים נוֹרָאִים
good! fine!	*tov*	טוֹב
good morning	*boker tov*	בֹּקֶר טוֹב
good evening	*erev tov*	עֶרֶב טוֹב
good night	*lailah tov*	לַיְלָה טוֹב
how good	*ki tov*	כִּי טוֹב
very good	*tov me'od*	טוֹב מְאֹד
the sixth day, Friday	*yom ha-shishi*	יוֹם הַשִּׁשִׁי

32 Varieties of Houses

From birth to death, we Jews seem to be surrounded by the word *bet* (sometimes transliterated as *beth* or *beit*). *Bet* means a "house of . . ." followed by its identifying function or description. *Bet* is a form of the Hebrew noun, *bayit* (pronounced bah'yit), meaning "home, house, household." Most of us are born in a *bet cholim*, hospital, literally, a "house of sick persons." From birth to death, we are members of *bet Yisrael*, the house of Israel. And, when we die, we are laid to rest in a *bet olam*, a house of eternity, or a *bet chayim*, a house of life—two euphemisms for a cemetery.

Between birth and death, we go to school, *bet sefer*. When we are grown, we set up a *bayit*, a household, of our own. We join a synagogue, which historically has three major functions: as a *bet tefilah*, a house of prayer; a *bet midrash*, a house of study; and a *bet knesset*, a house of assembly. As everyone knows, the parliament of the State of Israel is called the *Knesset*, literally, the "Assembly."

Other "house of . . ." phrases you may encounter: *bet ochel*, restaurant, house of food; *bet din*, law court, house of justice; *bet am*, community center, house of the people; and *bet kafeh*, coffeehouse, cafe, house of coffee.

Some synagogues incorporate *bet* or *beth* in their names: Beth Israel; Beth El or Beth Elohim which means house of God; or Beth Shalom meaning house of peace.

The master of the household or the landlord is the *ba'al bayit*, but the mistress of the household, the *ba'alat bayit*, is at times metaphorically called the *bayit*. Why? The poetic conception originated with the Sage, Jose ben Halafta, who once said: I have never called my wife "wife," but "home" (*bayit*).

Yiddish has borrowed the Hebrew terms, altered the pronunciations, and extended their meanings. The Yiddish term, *balebos*, is proprietor, owner, host, boss, master, or landlord, while the female counterpart, *baleboste*, is proprietor, owner, mistress, hostess, housekeeper, housewife, or landlady.

32 בַּיִת, בֵּית

Core words: בַּיִת, בֵּית

home, house, household	bayit	בַּיִת
house of . . .	bet . . .	בֵּית . . .
hospital	bet cholim	בֵּית חוֹלִים
house of Israel	bet Yisrael	בֵּית יִשְׂרָאֵל
cemetery	bet chayim בֵּית חַיִּים, bet olam	בֵּית עוֹלָם
school	bet sefer	בֵּית סֵפֶר
house of prayer	bet tefilah	בֵּית תְּפִלָּה
house of study	bet midrash	בֵּית מִדְרָשׁ
house of assembly	bet knesset	בֵּית כְּנֶסֶת
Israel parliament	Knesset	כְּנֶסֶת
restaurant	bet ochel	בֵּית אֹכֶל
law court [house of justice]	bet din	בֵּית דִּין
community center	bet am	בֵּית עָם
coffee house, cafe	bet kafeh	בֵּית קָפֶה
house of God	bet El בֵּית אֵל, bet Elohim	בֵּית אֱלֹהִים
house of peace	bet shalom	בֵּית שָׁלוֹם
master of the household, landlord	ba'al bayit	בַּעַל בַּיִת
mistress of the household	ba'alat bayit	בַּעֲלַת בַּיִת

71

33 Mothers and Fathers

The foundations of the Jewish family are the *em*, mother, and the *av*, father. More intimately within the family, they are *ima*, mama, mommy, and *aba*, dad, daddy. The Three Patriarchs, the *Sheloshah Avot*, of the Jewish people are *Avraham*, *Yitschak*, and *Ya'akov*. The Four Matriarchs, the *Arba Imahot*, are *Sarah*, *Rivkah*, *Rachel*, and *Leah*. Abraham's Hebrew name (Genesis 17:5) means "father," *av*, "of a multitude," *raham* (Arabic).

Eve, *Chavah* in Hebrew, was the *em kol chai*, mother of all living. The prophetess *Devorah*, Deborah, was called *em be-Yisrael*, mother in Israel. We hear more Hebrew expressions using *av* than *em*, a fact that distresses Jewish feminists. For instance, our ancestors conceived of God as the great *Av*, Father. We pray to the *Elohei Avotenu*, God of Our Fathers, now translated in *Gates of Prayer*, page 134, as "God of All Generations." On page 393 is the prayer, *Avinu Malkenu*, "Our Father, Our King," and on page 302 is the supplicatory prayer, *Ha-Av ha-Rachaman*, literally, "Father of Mercy," now translated as "Source of Mercy." *Pirkei Avot, Ethics of the Fathers*, is one of the most popular and beloved of all Jewish books.

The *av* and *em* together are the *horim*, parents, of their children. The *av* is the *horeh*, the male parent, and the *em* is the *horah*. The Hebrew verb meaning to "teach, instruct, show, point out to," is also *horah*. From the *horeh* and *horah*, you proceed to the *moreh*, male teacher, and the *morah*, female teacher. Ideally, the *horim* and the *morim*, parents and teachers, teach Torah to Jewish children. You will recall that Torah is not only another name for the *Chumash* but it is also a noun meaning moral and religious "instruction, teaching" (see chapter 5). From these related words, it is clear that, in the view of the Jewish tradition, a basic responsibility of Jewish *horim* and *morim* has always been to instruct children in the paths of Torah.

33 אִמָּהוֹת וְאָבוֹת

Core words: אָב, אֵם

mother, mothers	אֵם *em*, אִמָּהוֹת *imahot*
mama, mommy	אִמָּא *ima*
father, fathers	אָב *av*, אָבוֹת *avot*
dad, daddy	אַבָּא *aba*
the Three Patriarchs	שְׁלֹשָׁה אָבוֹת: אַבְרָהָם, יִצְחָק, יַעֲקֹב *Sheloshah Avot: Avraham, Yitschak, Ya'akov*
the Four Matriarchs	אַרְבַּע אִמָּהוֹת: שָׂרָה, רִבְקָה, רָחֵל, לֵאָה *Arba Imahot: Sarah, Rivkah, Rachel, Leah*
Eve: mother of all living	*Chavah: em kol chai* חַוָּה: אֵם כָּל חָי
Deborah: mother in Israel	*Devorah: em be-Yisrael* דְּבוֹרָה: אֵם בְּיִשְׂרָאֵל
"God of Our Fathers [All Generations]"	*Elohei Avotenu* אֱלֹהֵי אֲבוֹתֵינוּ
"Our Father, Our King"	*Avinu Malkenu* אָבִינוּ מַלְכֵּנוּ
"Father [Source] of Mercy"	*Ha-Av ha-Rachaman* הָאָב הָרַחֲמָן
Ethics of the Fathers	*Pirkei Avot* פִּרְקֵי אָבוֹת
parents	*horim* הוֹרִים
parent	*horeh* (masc.) הוֹרֶה, *horah* (fem.) הוֹרָה
teach, instruct, show, point out to	*horah* הוֹרָה
teacher	*moreh* (masc.) מוֹרֶה, *morah* (fem.) מוֹרָה
teachers	*morim* (masc.) מוֹרִים, *morot* (fem.) מוֹרוֹת

73

34 How Good and How Pleasant

Any Jewish lexicon ought to contain more than individual words and phrases. Lines and verses from the *Tanach* should also be included. Many of them have been set to music, so that learning and singing them as songs can be a pleasure. As a start, look up the opening verse of Psalm 133. Does it seem familiar? It ought to: It's the famous *Hineh Mah Tov* that has been sung for centuries in countless variations. The full passage is: *Hineh mah tov u-mah na'im shevet achim gam yachad*, Behold, how good and how pleasant it is for brethren to dwell together in unity.

Hineh, behold, in old Bible translations, is used as an interjection the way we would say "Look!" One of the memorable usages of *hineh* occurs (Genesis 28:15) when the sleeping Jacob dreams that God, standing beside him, is saying: *Ve-hineh, anochi imach*, And, behold [or remember], I am with you. The phrase, *mah tov u-mah na'im*, how good and pleasant it is, echoes the Creation story when God looked over all that He made "and, behold, it was very good, *ve-hineh, tov me'od*" (Genesis 1:31). Everyone knows *tov*, but *na'im*, pleasant, agreeable, may be new. The name "Naomi" comes from *na'im*. In modern Israel, upon being introduced to someone, one frequently hears: "*Na'im me'od*, Pleased to meet you."

The second half of *Hineh Mah Tov* reads: *shevet achim gam yachad*. The word *shevet* means "sitting." The Hebrew verb *yashav* means to "sit, sit down, stay, remain, dwell." In pre-State Palestine, the Jewish community was called the *yishuv*, the settlement, colony. *Achim*, brothers (singular, *ach*), is familiar from the story of Joseph and his brothers (Genesis 37). The final phrase in the verse, *gam yachad*, means "together."

Nowadays, we would do well to alter the song to bring in sisters, *achayot* (singular, *achot*). How much more pleasant it is when *achim* and *achayot* dwell together in unity!

Core words: אַחִים, אֲחָיוֹת

behold, how good and how pleasant it is	הִנֵּה מַה טוֹב וּמַה נָּעִים *hineh mah tov u-mah na'im*
for brethren to dwell together in unity	שֶׁבֶת אַחִים גַּם יָחַד *shevet achim gam yachad*
And, behold [or remember], I am with you.	וְהִנֵּה, אָנֹכִי עִמָּךְ. *Ve-hineh, anochi imach.*
And, behold, it was very good.	וְהִנֵּה, טוֹב מְאֹד. *Ve-hineh, tov me'od.*
pleasant, agreeable	*na'im* נָעִים
pleased to meet you	*na'im me'od* נָעִים מְאֹד
sitting	*shevet* שֶׁבֶת
sit, sit down, stay, remain, dwell	*yashav* יָשַׁב
settlement, colony	*yishuv* יִשׁוּב
brother	*ach* אָח
brothers	*achim* אַחִים
together in unity, as one	*gam yachad* גַּם יָחַד
sister	*achot* אָחוֹת
sisters	*achayot* אֲחָיוֹת

35 *Le-Chayim!*

When we Jews offer a toast, we say: *Le-chayim!* To life! The proper response is: *Le-chayim tovim u-le-shalom*, To a good life and to peace. Life, *chayim* (it is a plural noun), is a precious gift from God. The saving of endangered *chayim* takes precedence over virtually all Jewish laws, including the laws of the *Shabbat*.

In the prayer book you will find many references to the Torah as our *Ets Chayim*, Tree of Life. On the High Holy Days, we pray to be inscribed in the *Sefer Chayim*, Book of Life.

The verb, to "live, be alive," is *chayah*, and a related verb, meaning to "preserve alive, revive," is *hecheyah*. This latter verb gives us the base of the *Shehecheyanu* blessing that is recited before the festivals and joyous events. In this blessing, we thank God "for giving us life, and for sustaining us, and for enabling us to reach this season [this particular joyous moment]." (The full text and translation of *Shehecheyanu* appears in *Gates of Prayer*, page 722.)

The adjective for "living, alive, healthy, fresh" is the familiar *chai*, a word that is engraved upon lockets or charms worn by many Jews. All Hebrew letters have a numerical value. *Chai* is made up of two Hebrew letters—*chet* (8) and *yod* (10)—which together add up to 18. Very often Jews make symbolic gifts of 18—dollars, hundreds of dollars, thousands of dollars—or multiples of 18. These gifts literally carry with them hopes and wishes for *chai* and *chayim*.

We've had many illustrious *Chayims* in Jewish history, although the English spellings may vary, including: Dr. Chaim Weizmann, the scientist and first president of the State of Israel; Chaim Nachman Bialik, the great Hebrew poet; Haym Salomon, the American Revolutionary War patriot; Hayyim Hazaz, the contemporary Hebrew writer; and Chaim Grade, the Yiddish novelist and poet.

35 לְחַיִּים!

Core words: חַיִּים, חָיָה

to life	לְחַיִּים *le-chayim*
to a good life and to peace	לְחַיִּים טוֹבִים וּלְשָׁלוֹם *le-chayim tovim u-le-shalom*
life	חַיִּים *chayim*
Tree of Life	עֵץ חַיִּים *Ets Chayim*
Book of Life	סֵפֶר חַיִּים *Sefer Chayim*
live, be alive	חָיָה *chayah*
preserve alive, revive	הֶחֱיָה *hecheyah*
"Who Has Given Us Life"	שֶׁהֶחֱיָנוּ *Shehecheyanu*
living, alive, healthy, fresh	חַי *chai*

36 Happiness Is . . .

The Jewish lexicon has a number of delightful words conveying the idea of joy and happiness. The best known is based on the three-letter Hebrew root, *sin-mem-chet*, equivalent to the English *s-m-ch*. The verb, "rejoice, be glad," is *samach*. The adjective, *same'ach*, means "glad, joyful," and the noun is *simchah*, joy, happiness, festivity, glad occasion. Most Jews know this cluster of words. "Happy holiday" is *chag same'ach*. The festival, *Simchat Torah*, is literally the "Rejoicing of the Law." Congregations and families rejoice throughout the year with many *semachot* (plural of *simchah*), such as weddings, *bar/bat mitzvah* ceremonies, and the like. In Yiddish, the pronunciation is *simkhe* and *simkhes*.

Simchah is a popular Hebrew name for boys or girls, but other happy names also abound. *Rinah* (or Rena) means "song, music." *Ran*, to sing, chant, is a name for boys. Still another form of the name is *Renanah*, songs of joy, joyful music. A synonym for "joy" is *Gil*, a boy's name; the feminine form is *Gilah*. *Chedvah*, joy, gladness, is a feminine name. An enchanting name *Alizah* is the feminine adjective meaning "merry, gay." The boy's names, *Esher* or *Osher*, mean "happiness, bliss." At the opening of the familiar Psalm 112, we exclaim, *Ashrei* . . . , happy is . . . , blessed is . . . , fortunate is. . . .

We are indebted to the Hebrew poet, Chaim Nachman Bialik, for introducing the idea of the *Oneg Shabbat* into the life of our people. He started the custom of celebrating the afternoon of the Sabbath by Jewish cultural activities in pre-State Palestine. The Hebrew nouns for "joy, pleasure, delight" are *oneg* or *ta'anug*. The phrase, *oneg Shabbat*, is literally the "joy of the Sabbath."

שִׂמְחָה 36

Hebrew root: שׂ-מ-ח

rejoice, be glad	*samach* שָׂמַח
glad, joyful	*same'ach* שָׂמֵחַ
joy, happiness, festivity, glad occasion	*simchah* שִׂמְחָה
joys, festivities, glad occasions	*semachot* שְׂמָחוֹת
happy holiday	*chag same'ach* חַג שָׂמֵחַ
Rejoicing of the Law	*Simchat Torah* שִׂמְחַת תּוֹרָה
song, music	*rinah* רִנָּה
sing or chant	*ran* רַן
joyful music, songs of joy	*renanah* רְנָנָה
joy	*gil* גִּיל
joy, rejoicing	*gilah* גִּילָה
joy, gladness	*chedvah* חֶדְוָה
merry, gay	*alizah* (fem.) עַלִיזָה
happiness, bliss	*esher* אֶשֶׁר, *osher* אֹשֶׁר
fortunate is . . . , happy is . . . , blessed is . . .	*ashrei* . . . אַשְׁרֵי . . .
joy, pleasure, delight	*ta'anug* תַּעֲנוּג, *oneg* עֹנֶג
joy of the Sabbath	*oneg Shabbat* עֹנֶג שַׁבָּת

37 To Your Health!

The Hebrew verb, *bara*, create, appears as the second word in the opening of *Bereshit*. The root letters, *bet-resh-alef*, form a stimulating cluster of words. For example, the noun, "creation," *beriah*, comes from this root. Since God the Creator (called *Borei peri ha-gafen*, "Creator of the fruit of the vine," in the familiar blessing over wine) viewed all His *beriah* as *tov*, we take it for granted that the first two human creations were completely *bari*, sound, healthy. It is only a step away from *beriah* to *beriut*, health, soundness. Instead of saying *gesundheit* when a person sneezes, in Hebrew we say *La-beriut*, To health.

Beriut is sometimes found in context with words having to do with healing. The verb, *rafa* to heal, is spelled *resh-fei-alef*. A "physician, medical doctor" in Hebrew is a *rofe* (feminine, *rofah*). Doctors use their medical (*refui*) knowledge to effect a *refuah*, recovery. The expression used to wish a sick person "a complete recovery" is *refuah shelemah*. The adjective, *shelemah*, is related to *shalom*, one of whose definitions is "completeness, wholeness" (see chapter 11).

Now the meaning of the name Raphael or Rafael should be clear. The *el* ending signifies God; the prefix is spelled *resh-fei-alef*, heal. Put the syllables together and you get the name of the archangel Raphael or Rafael (God is healing) of Jewish legend. His function was to be a messenger of God for the special purpose of healing. God himself is the great Healer of the sick, *rofe h-cholim*. The prayer for *refuah* appears in *Gates of the House*, page 164. Incidentally, *bikur cholim*, visiting the sick, either in their own *bayit* or in a *bet cholim*, hospital, is a great *mitzvah* in the Jewish tradition. Although many congregants expect their rabbi to perform this *mitzvah* in their behalf, *all* Jews have the religious obligation to carry out *bikur cholim*.

37 לַבְּרִיאוּת!

Hebrew roots: ב-ר-א, ר-פ-א

create	bara בָּרָא
creation	beriah בְּרִיאָה
Creator of the fruit of the vine	בּוֹרֵא פְּרִי הַגָּפֶן Borei peri ha-gafen
sound, healthy	bari בָּרִיא
health, soundness	beriut בְּרִיאוּת
to health	la-beriut לַבְּרִיאוּת
heal	rafa רָפָא
physician, medical doctor	rofe (masc.) רוֹפֵא rofah (fem.) רוֹפְאָה
medical	refui רְפוּאִי
recovery [from illness]	refuah רְפוּאָה
complete recovery	refuah shelemah רְפוּאָה שְׁלֵמָה
God is healing, name of the archangel Raphael [or Rafael]	refael רְפָאֵל
healer of the sick	rofe ha-cholim רוֹפֵא הַחוֹלִים
hospital	bet cholim בֵּית חוֹלִים
visiting the sick	bikur cholim בִּקוּר חוֹלִים

38 Let There Be Light!

The first words uttered by God in the *Tanach* are: *Yehi or*, Let there be light. And in that same instant, *va-yehi or*, and there was light (Genesis 1:3). "Light, brightness" in Hebrew is *or*.

Shortly after God creates *or*, He places two great lights in the sky. "The greater light," *ha-ma'or ha-gadol* [the sun], dominates the day; and "the lesser light," *ha-ma'or ha-katon* [the moon], dominates the night (Genesis 1:16).

Apart from the sun and the moon, what is used here on earth to shed *or*? The answer is *ner*, candle, lamp, light. Every synagogue has a *Ner Tamid*, Eternal Light, in accordance with the command in Exodus 27:20 to have "a lamp to burn continually" in the tabernacle. We light *nerot* (plural) for Shabbat and the holidays. We often hear the expressions, *ner shel yom tov, ner shel Chanukah, ner shel Shabbat*, to mean the "light" of these special days. In modern Hebrew, a "light bulb" is a *nurah*.

The *nerot*, of course, are placed in a *menorah*, candelabrum. In the days of the Temple in Jerusalem, the *menorah* was a majestic seven-branched candelabrum. In Jewish tradition, six branches signify the six days of the Creation, and the seventh in the center signifies the *Shabbat*. The great Temple *menorah* was carried away as booty by the Romans when they destroyed Jerusalem in 70 B.C.E. Travelers to Rome today can still see that splendid *menorah* carved into the Arch of Titus. A magnificent modern *menorah* now stands outside the Knesset building in Jerusalem.

The Chanukah *menorah* has eight branches for the eight days of the festival. The proper name for it is not *menorah* but *chanukiyah*. There is, of course, an additional branch to hold the *shamash* or "server" candle.

38 יְהִי אוֹר!

Core words: אוֹר, מְנוֹרָה, נֵר

Let there be light	*Yehi or* יְהִי אוֹר
and there was light	*va-yehi or* וַיְהִי אוֹר
light, brightness	*or* אוֹר
the greater light [the sun]	*ha-ma'or ha-gadol* הַמָּאוֹר הַגָּדֹל
the lesser light [the moon]	*ha-ma'or ha-katon* הַמָּאוֹר הַקָּטֹן
candle, lamp, light	*ner* נֵר
Eternal Light	*Ner Tamid* נֵר תָּמִיד
candles, lights	*nerot* נֵרוֹת
light of a holiday	נֵר שֶׁל יוֹם טוֹב *ner shel yom tov*
light of Chanukah	נֵר שֶׁל חֲנֻכָּה *ner shel Chanukah*
light of Sabbath	נֵר שֶׁל שַׁבָּת *ner shel Shabbat*
light bulb	*nurah* נוּרָה
candelabrum	*menorah* מְנוֹרָה
Chanukah candelabrum	*chanukiyah* חֲנֻכִּיָּה

39 Forming Fellowships

We've been hearing much lately about *chavurot*, fellowships, companies, bands, groups (singular, *chavurah*). They seem to be springing up all over the country both inside and outside the synagogue. The impulse to form a *chavurah* appears especially strong in the larger congregations where certain members wish to form smaller groups of individuals or families for Jewish study, worship, and the performance of *mitzvot*.

The three-letter Hebrew root, *chet-vet-resh*, equivalent to the English *ch-v-r*, gives us the verb, *chavar*, which means to "unite, join together, form an association." The Hebrew noun, *chaver* (masculine, plural, *chaverim*), means "friend, associate, companion, partner, member of an association." The feminine is *chaverah* (plural, *chaverot*). A famous old Hebrew saying goes: *Chaverim kol Yisrael*, All Jews are bound together in fellowship. *Kol Yisrael arevim zeh ba-zeh*, All Jews are responsible for one another, is another concept we have been demonstrating throughout our history by helping Jews in distress wherever they may live.

The term *chevrah* has long been used to denote a formal membership "society, company, association" for Jewish religious, educational, and philanthrophic purposes within the Jewish community. Jews would form a *chevrah*, for instance, to carry out such tasks as visiting the sick, ransoming Jewish captives, and providing dowries for poor Jewish brides. The best known of all these associations is the *Chevrah Kadisha*, holy or sacred society, formed for the purpose of supervising burial arrangements and burying the dead. As we have already noted in examining the concept of *chesed* (see chapter 15), burying the dead is a sacred responsibility that is part of practicing *gemilut chasadim*. In times gone by, Jews considered it a great honor to be a member of the *Chevrah Kadisha*. With the increased interest in death and dying in the last decade, some congregations are paying renewed attention to reviving the institution of the *Chevrah Kadisha*.

39 חֲבוּרוֹת

Hebrew root: ח-ב-ר

fellowship, company, band, group	*chavurah* חֲבוּרָה
fellowships, companies, bands, groups	*chavurot* חֲבוּרוֹת
unite, join together, form an association	*chavar* חָבַר
friend, associate, companion, partner, member of an association	*chaver* (masc.) חָבֵר
	chaverah (fem.) חֲבֵרָה
friends, associates, companions, partners, members of an association	*chaverim* (masc.) חֲבֵרִים
	chaverot (fem.) חֲבֵרוֹת

All Jews are bound together in fellowship.

חֲבֵרִים כָּל יִשְׂרָאֵל.
Chaverim kol Yisrael.

All Jews are responsible for one another.

כָּל יִשְׂרָאֵל עֲרֵבִים זֶה בָּזֶה.
Kol Yisrael arevim zeh ba-zeh.

formal membership society, company, association *chevrah* חֶבְרָה

holy or sacred society, formed especially to arrange the burial of the dead *Chevrah Kadisha* חֶבְרָה קַדִישָׁא

40 The Power of the Tongue

Lashon means "tongue, language, speech." English, of course, is a modern *lashon*, and so, also, is *Ivrit*, Hebrew. Our Jewish lexicon has two familiar expressions that use a form of the Hebrew word *lashon* to convey two ideas—one positive and one negative.

For over 2,000 years, Hebrew has always been called the *leshon ha-kodesh*, the holy tongue, to differentiate it from the numerous other languages Jews have used in daily life. Despite the centuries of wandering and of living in strange lands, Jews have kept the *leshon ha-kodesh* as their language for prayer, worship, and Jewish scholarship. No matter where Jews lived, they managed to keep the *leshon ha-kodesh* alive so that, today, *Ivrit* is a vibrant, living, modern language.

The second expression is not a happy one. It is *leshon ha-ra*, meaning "slander, evil gossip, evil speech." Leviticus 19:16, in the 1917 Jewish Publication Society translation, specifically warns: You shall not go up and down as a talebearer among your people. The Rabbis considered slander to be a heinous crime, as bad even as murder or idolatry. The wicked, careless, malicious *lashon* can ruin a reputation, stir up strife, and cause injury beyond repair. Said the Rabbis: *Leshon ha-ra* harms three: the person who tells it, the one who hears it, and the one who is slandered. Even unkind remarks about a person were regarded as a form of slander—*avak leshon ha-ra*, literally, dust of slander, what today we might call "fallout." The Rabbis were ahead of their time in recognizing the harm caused by *leshon ha-ra*. If they were horrified by *leshon ha-ra* in their day, when news took months or years to circulate, consider how they would react today, when words are flashed around the world in an instant. The power of the *lashon* is awesome!

40 לָשׁוֹן

Core word: לָשׁוֹן

tongue, language, speech	*lashon* לָשׁוֹן
the Hebrew language	*Ivrit* עִבְרִית
[Hebrew], the holy tongue	*leshon ha-kodesh* לְשׁוֹן הַקֹּדֶשׁ
bad, wicked, malignant, evil	*ra* (masc.) רַע
	ra'ah (fem.) רָעָה
wickedness, harm, evil	*ra* רַע
slander, evil gossip, evil speech	*leshon ha-ra* לְשׁוֹן הָרָע
a slight suggestion of slander [literally, dust of slander]	אֲבַק לְשׁוֹן הָרָע *avak leshon ha-ra*

41 Numbers Game

How many *misparim*, numbers (singular, *mispar*), do you know? Probably far more than you think. We find many *misparim* in the Passover song, *Echad Mi Yodea?* "Who Knows One?" and in traditional Jewish phrases. How many of the following do you recognize?*

Whenever you recite the *Shema*, you say the *mispar* "one." The final phrase, *Adonai Echad*, means "the Lord is One." According to tradition, Moses received *Shenei Luchot ha-Berit*, the Two Tablets of the Covenant, on Mount Sinai. We have Three Pilgrim Festivals, the *Shalosh Regalim*, in the Jewish year: *Pesach*, *Shavuot*, and *Sukot*. To celebrate these festivals, Jews in the days of the Temple used to *walk* up to Jerusalem, hence the word *regalim*, legs, feet, in the phrase. We also have the Three Patriarchs, the *Sheloshah Avot*. The *mispar* "four" occurs in the phrase, the *Arba Imahot*, the Four Matriarchs.

The number "five" is easy. The Book of Esther is one of the Five Scrolls we call the *Chamesh Megillot*. The *mispar* "six" is more elusive: the *Shishah Sidrei Mishnah*, the Six Orders [or sections] of the Mishnah.

With "seven," we are back on familiar ground. The traditional Jewish seven-day mourning period is called *shivah*. "Eight," *shemoneh*, appears in the well-known phrase, *Shemoneh Ma'alot bi-Tsedakah*, the Eight Degrees of (giving) *Tsedakah*, formulated by Moses Maimonides. (The English translation appears in *Gates of Prayer*, page 15.) We know the number "nine" from the date, *Tishah be-Av*, *the Ninth of Av*, which marks the destruction of the First and Second Temples in Jerusalem.

The *mispar* "ten" provides a field day. The Decalogue has the Hebrew name, *Aseret ha-Dibrot*, the Ten Commandments. The "Ten Lost Tribes" are called the *Aseret ha-Shevatim;* and the Ten Days of Repentance between Rosh Hashanah and Yom Kippur are known as the *Aseret Yemei Teshuvah*.

* Cardinal and ordinal numbers in Hebrew have masculine and feminine forms according to the gender of the nouns to which they are attached. We are here presenting only the forms used in the sample phrases. Consult a Hebrew grammar for all the various forms of Hebrew numbers.

41 מִסְפָּר

Core word: מִסְפָּר

number, numbers	מִסְפָּר, mispar מִסְפָּרִים misparim
"Who Knows One?"	אֶחָד מִי יוֹדֵעַ? Echad Mi Yodea?
the declaration of God's unity, "hear"	שְׁמַע Shema
the Lord is One	יְיָ אֶחָד Adonai Echad
the Two Tablets of the Covenant	שְׁנֵי לוּחוֹת הַבְּרִית Shenei Luchot ha-Berit
the Three Pilgrim Festivals	שָׁלֹשׁ רְגָלִים: פֶּסַח, שָׁבוּעוֹת, סֻכּוֹת Shalosh Regalim: Pesach, Shavuot, Sukot
legs, feet	רְגָלִים, regalim רַגְלַיִם raglayim
the Three Patriarchs	שְׁלֹשָׁה אָבוֹת Sheloshah Avot
the Four Matriarchs	אַרְבַּע אִמָּהוֹת Arba Imahot
the Five Scrolls	חָמֵשׁ מְגִלּוֹת Chamesh Megillot
Six Orders of the Mishnah	שִׁשָּׁה סִדְרֵי מִשְׁנָה Shishah Sidrei Mishnah
seven-day mourning period	שִׁבְעָה shivah
Eight Degrees of (giving) Tsedakah	שְׁמֹנֶה מַעֲלוֹת בִּצְדָקָה Shemoneh Ma'alot bi-Tsedakah
the Ninth of Av	תִּשְׁעָה בְּאָב Tishah be-Av
the Ten Commandments	עֲשֶׂרֶת הַדִּבְּרוֹת Aseret ha-Dibrot
the Ten Lost Tribes	עֲשֶׂרֶת הַשְּׁבָטִים Aseret ha-Shevatim
Ten Days of Repentance	עֲשֶׂרֶת יְמֵי תְשׁוּבָה Aseret Yemei Teshuvah

Section Four

Blessings in Synagogue and Home

42 Work and Worship

The Hebrew noun, *avodah*, has several meanings: "service" in the sense of "worship" and "service" in the sense of "work, labor, employment." The three-letter Hebrew root, *ayin-vet-dalet*, spells the verb, *avad*, to work.

A "servant, slave" in Hebrew is *eved*. The patriarchs, Moses, and other biblical personalities are called in the text: *eved Adonai*, servant of the Lord. In transmitting the words of the Lord to the people Israel, the prophets (e.g., Isaiah 41:8) used the phrase, *Yisrael avdi*, Israel, My servant, in the collective sense.

The Book of Exodus records the story of our slavery, *avdut*, in Egypt. In Exodus 1:14, we are told that the Egyptians made the lives of the Israelites bitter *ba-avodah kashah*, with hard service. Later, when Moses goes to complain at court, Pharaoh is obdurate. "Let heavier work, *avodah*, be laid upon the men," he says (Exodus 5:9). The rescue of the Israelites *mi-bet avadim*, from the house of bondage, is detailed in Exodus and also in the *Haggadah shel Pesach*. Deuteronomy 10:12-13 explains to the newly freed slaves what the Lord requires of them, among which is the obligation to love Him and to serve, *la-avod*, Him.

In the days of the Temple, the priests recited the *Avodah* ("Worship" prayer) after offering up sacrifices to the Lord. The traditional *Avodah* asks for the restoration of the worship service of the ancient Temple and beseeches God to "receive in love and favor [the offerings and] the prayers of Israel." The Reform *Avodah* (see *Gates of Prayer*, page 137) modifies this to "receive our prayers with love."

The Second Commandment prohibits idolatry: *Lo to'ovdem*, You shall not serve them [idols]. The ancients had a phrase for idolatry: *avodah zarah*, foreign, strange service, worship, that is, the idolatry and pagan practices abhorred by the Redeemer of Israel who rescued His children *mi-bet avadim*.

42 עֲבוֹדָה

Hebrew root: ע-ב-ד

worship	avodah עֲבוֹדָה
work, labor, employment	avodah עֲבוֹדָה
work (verb)	avad עָבַד
servant, slave	eved עֶבֶד
servant of the Lord	eved Adonai עֶבֶד יְיָ
Israel, My servant	Yisrael avdi יִשְׂרָאֵל עַבְדִּי
slavery	avdut עַבְדוּת
with hard service	ba-avodah kashah בַּעֲבֹדָה קָשָׁה
from the house of bondage	mi-bet avadim מִבֵּית עֲבָדִים
to serve	la-avod לַעֲבֹד
"Worship" prayer	Avodah עֲבוֹדָה
you shall not serve them [idols]	lo to'ovdem לֹא תָעָבְדֵם
idolatry	avodah zarah עֲבוֹדָה זָרָה

43 The Eternal Covenant

One way to understand the essence of Judaism is to consider the implications of the word, *berit*, covenant, pact, treaty. At the dawn of our history as a people, shortly after the redemption from slavery in Egypt, God and *Benei Yisrael* entered into an everlasting *berit*. In return for the people's pledge to serve Him exclusively, and forever, and to carry out His laws and teachings, God promised to give them His eternal protection and a land flowing with milk and honey. Long before that, God had made a covenant with Abraham (Genesis 15 and 17) and, as an *ot berit*, token of covenant, Abraham and all the males of his household underwent circumcision. To this day, *berit milah*, circumcision, is a sign of the covenant between God and the *Benei Berit* (sometimes transliterated as *B'nai B'rith*).

Despite their solemn pledge of loyalty to God—"All that the Lord has spoken will we do and obey" (Exodus 24:7)—the *Benei Yisrael* immediately fell to worshiping the golden calf, even as Moses was atop Sinai receiving the *Shenei Luchot ha-Berit*, the Two Tablets of the Covenant. Moses angrily smashed the first set (Exodus 32:19; Deuteronomy 9:7-29, 10:1-5); and only with great difficulty was he able to persuade God to forgive the people. God then inscribed a second set of tablets which Moses placed in the *Aron ha-Berit*, the Ark of the Covenant. The history of Israel after that momentous episode in the wilderness was a long and dismal series of defections by the people, followed by periods of remorse. As they were to learn the hard way, the *Benei Berit* could not breach the *berit* with impunity.

The word *berit* also appears in the *Tanach* in connection with other covenants. The rainbow is an *ot berit*, a sign of God's promise to Noah (Genesis 9:12) that never again would He send a flood to destroy life on earth. The *Shabbat*, too, is an *ot*, a sign between God and the people: The Israelite people shall keep the Sabbath . . . throughout the ages as a *berit olam*, covenant for all time (Exodus 31:16).

43 בְּרִית

Core word: בְּרִית

covenant, pact, treaty	בְּרִית *berit*
Children of Israel	*Benei Yisrael* בְּנֵי יִשְׂרָאֵל
a token or sign of a covenant	*ot berit* אוֹת בְּרִית
circumcision	*berit milah* בְּרִית מִילָה
Children of the Covenant	*Benei Berit* בְּנֵי בְּרִית (sometimes, *B'nai B'rith*)
the Two Tablets of the Covenant	שְׁנֵי לוּחוֹת הַבְּרִית *Shenei Luchot ha-Berit*
Ark of the Covenant	*Aron ha-Berit* אֲרוֹן הַבְּרִית
All that the Lord has spoken will we do and obey.	כֹּל אֲשֶׁר דִּבֶּר יְהֹוָה נַעֲשֶׂה וְנִשְׁמָע. *Kol asher diber Adonai na'aseh ve-nishma.*
an everlasting covenant	*berit olam* בְּרִית עוֹלָם

44 The Divine King

In these days of dwindling monarchies, the word "king" sounds anachronistic. Yet, in our Jewish prayers, we are constantly addressing our *Melech ha-olam*, King of the universe, and imploring the aid of *Avinu Malkenu*, our Father, our King. We acknowledge that He is the *Melech malchei ha-melachim*, supreme King of kings (*Gates of Prayer*, page 178) and give Him our allegiance: *En lanu Melech ela Atah*, We have no King but You (page 297). We say: *Baruch shem kevod malchuto le-olam va-ed*, Blessed is His glorious kingdom for ever and ever (page 224). The language may be anachronistic, but, even in this age of space exploration, it would be difficult to find a more sweeping and majestic phrase than *Melech ha-olam*, Ruler of the universe.

In the time of the prophet Samuel, the people rebelled against being different from their neighbors. They importuned Samuel: Make [appoint] us a king, *melech*, to judge us like all the nations (I Samuel 8:5). This was not the first time, nor would it be the last, that the people struggled against the terms of the covenant. Samuel tried to dissuade them by reminding them that they already had a king, a divine King, and by describing the miseries that would befall them under a human king. But they were adamant, and the divine King at last ordered Samuel to "make them a king, *melech*" (8:22). Thus began the period of the human kings, the *melachim*, in Jewish history. Two books of the *Tanach* entitled *Melachim*, Kings, record what happened under the rule of the *melachim* of Judah and of Israel. Incidentally, unlike the practices in some other ancient societies, the Jewish kings were never worshiped as gods; nor did they take over the functions of the priesthood.

The reigns of our human *melachim*, even of the illustrious *Shelomoh ha-Melech*, often ended in tragedy. Under one queen, *Esther ha-Malkah*, we came close to annihilation. But, under the gentle ministrations of another queen, *Shabbat ha-Malkah* (*Gates of Prayer*, page 733), we have known rest and respite from the tyrannies of earthly *melachim*.

44 מֶלֶךְ הָעוֹלָם

Core words: מֶלֶךְ, מְלָכִים

King of the universe, Ruler of the universe	מֶלֶךְ הָעוֹלָם *Melech ha-olam*
our Father, our King	אָבִינוּ מַלְכֵּנוּ *Avinu Malkenu*
the supreme King of kings	מֶלֶךְ מַלְכֵי הַמְּלָכִים *Melech malchei ha-melachim*
We have no King but You.	אֵין לָנוּ מֶלֶךְ אֶלָּא אָתָּה. *En lanu Melech ela Atah.*
Blessed is His glorious kingdom for ever and ever!	בָּרוּךְ שֵׁם כְּבוֹד מַלְכוּתוֹ לְעוֹלָם וָעֶד! *Baruch shem kevod malchuto le-olam va-ed!*
king	מֶלֶךְ *melech*
kings	מְלָכִים *melachim*
queen	מַלְכָּה *malkah*
queens	מְלָכוֹת *melachot*
two books of the *Tanach:* I Kings and II Kings	מְלָכִים א' *Melachim Alef* מְלָכִים ב' *Melachim Bet*
Esther the Queen	אֶסְתֵּר הַמַּלְכָּה *Esther ha-Malkah*
the Sabbath Queen	שַׁבָּת הַמַּלְכָּה *Shabbat ha-Malkah*

45 The Idea of Holiness, Part I

On virtually every page of the *siddur*, one finds a critically important Jewish concept repeated in various forms. The core of the Hebrew word expressing this concept always consists of the same three Hebrew letters—*kof-dalet-shin*, equivalent to *k-d-sh* in English. By adding different vowels and at times even more consonants, we get a number of words, all of them conveying in some way the Jewish idea of "holiness, sanctity, sanctification."

For example, before the Shabbat or festival dinner or other joyous occasions, we recite the *Kiddush*, the sanctification [over wine, the symbol of joy]. If the family has no wine, the *Kiddush* can also be made over two loaves of bread, symbols of the double portion of manna collected by the Children of Israel on the day before the Shabbat in the wilderness of Sinai. (The text of the *Kiddush* for the eve of the Shabbat and of the *Yom Tov* appears in *Gates of Prayer*, pages 777-778.)

If Jews know little else about Jewish life, they know the moving Mourner's *Kaddish*, the powerful prayer that opens: *Yitgadal ve-yitkadash*. This prayer makes no mention whatever of death but is a glorification of God, a positive reaffirmation of faith at a time of deep bereavement (*Gates of Prayer*, pages 629-630). The *Kaddish* is not written in Hebrew but in Aramaic, a Semitic language that was spoken widely in the Middle East some 2,000 years ago. (There are traces of Aramaic in the Hebrew Bible, in Jeremiah 10:11, Daniel 2:4-7:28, Ezra 4:8-6:18 and 7:12-26; even Genesis [31:47] has two Aramaic words.)

The great *Kedushah* prayer (it, too, means "sanctification") opens: *Nekadesh et shimcha*, We sanctify Your name, inviting the congregation to join in praise of God. This leads into the marvelous utterance: *Kadosh, kadosh, kadosh Adonai tsevaot*, Holy, holy, holy is the Lord of hosts (*Gates of Prayer*, pages 79-80). These soaring words are taken from Isaiah 6:3, in which the prophet describes his vision of the heavenly hosts calling out to one another: Holy, holy, holy is the Lord of hosts; the whole earth is full of His glory.

Hebrew root: שׁ-ד-ק

become holy, be consecrated	קָדַשׁ *kadash*
sanctify	קִדֵּשׁ *kidesh*
sanctification over wine on the eve of Shabbat and holidays	קִדּוּשׁ *Kiddush*
Mourner's Kaddish, the prayer that opens with the words: Let the glory of God be extolled, let His great name be hallowed.	קַדִּישׁ *:Kaddish*

יִתְגַּדַּל וְיִתְקַדַּשׁ שְׁמֵהּ רַבָּא.
Yitgadal ve-yitkadash shemeh raba.

"Sanctification," the prayer that opens with the words: We sanctify Your name

קְדֻשָּׁה *:Kedushah*

נְקַדֵּשׁ אֶת שִׁמְךָ
Nekadesh et shimcha

Holy, holy, holy is the Lord of Hosts.

קָדוֹשׁ, קָדוֹשׁ, קָדוֹשׁ
יְיָ צְבָאוֹת.
Kadosh, kadosh, kadosh
Adonai tsevaot.

46 The Idea of Holiness, Part II

The Jewish lexicon is rich in words expressing the concept of "holiness, sanctity." All the words have as their core the three Hebrew consonants, *kof-dalet-shin*, transliterated into English as *k-d-sh*. For instance, the Holy Ark is the *Aron ha-Kodesh*. The Temple in Jerusalem is known as the *Bet ha-Mikdash*. Scriptures or the Holy Writ is *Kitvei ha-Kodesh*. All human life is sacred, a principle we express in the phrase, *kedushat ha-chayim*.

Some of these *k-d-sh* words may be unfamiliar, but many Jews have heard the blessing over lighting the candles at home on the eve of the Shabbat and the festivals. A passage in the blessing goes: *Asher kideshanu be-mitzvotav*, By whose *mitzvot* we are hallowed. Another term we ought to know better is *kiddushin*, referring to the betrothal or the Jewish marriage rite, during which the groom "sanctifies" his bride to himself. Marriage is a sacred, *kadosh*, institution in the sight of God, according to the Jewish view. As he places the plain gold ring on his bride's finger, the groom says in part: *At mekudeshet li*, You are consecrated unto me.

Kiddush ha-Shem, the sanctification of God's name, is a noble expression reserved for those who perish for the sake of God. The six million Jews killed in the Holocaust can be said to have died as martyrs, upholding the principle of *Kiddush ha-Shem*.

Over the centuries, Jews preserved the Hebrew language as the *leshon ha-kodesh*, the holy tongue (see chapter 40), and even today, when Hebrew has been revived as a living language, there are pious Jews who still refuse to use the *leshon ha-kodesh* except for religious or study purposes. Two centuries ago, the colonial American Hebraist, the Rev. Ezra Stiles, president of Yale University, made the study of Hebrew compulsory for Yale freshmen—also for religious purposes. He was fearful lest a student die and ascend to heaven without knowing the *leshon ha-kodesh*. For, without the sacred tongue, how could the poor soul possibly converse with the angels?

46 קָדוֹשׁ

Hebrew root: שׁ-ד-ק

the Holy Ark	*Aron ha-Kodesh* אֲרוֹן הַקֹּדֶשׁ
the (now destroyed) Temple in Jerusalem	*Bet ha-Mikdash* בֵּית הַמִּקְדָּשׁ
Scriptures, the Holy Writ	*Kitvei ha-Kodesh* כִּתְבֵי הַקֹּדֶשׁ
sanctity of [or reverence for] human life	*kedushat ha-chayim* קְדֻשַׁת הַחַיִּים

by whose *mitzvot* we are hallowed

אֲשֶׁר קִדְּשָׁנוּ בְּמִצְוֹתָיו
asher kideshanu be-mitzvotav

Jewish betrothal or marriage rite	*kiddushin* קִדּוּשִׁין
sacred, holy, sanctified	*kadosh* קָדוֹשׁ

You are consecrated unto me.

אַתְּ מְקֻדֶּשֶׁת לִי.
At mekudeshet li.

martyrdom [literally, "sanctification of God's name"]	*Kiddush ha-Shem* קִדּוּשׁ הַשֵּׁם
[Hebrew], the holy tongue	*leshon ha-kodesh* לְשׁוֹן הַקֹּדֶשׁ

47 The Idea of Holiness, Part III

Why do we have so many words and phrases that express—through the Hebrew root, *k-d-sh*—the idea of "holiness, sanctity"? The answer is that, very early in our history, we conceived of God as *ha-Kadosh, baruch Hu*, the Holy One, blessed be He, and of His people Israel as a *goi kadosh*, holy nation. Leviticus 19:2, which is addressed to the entire congregation of Israel and not merely to the priests, summarizes the concept: *Kedoshim tiheyu; ki kadosh Ani Adonai Elohechem*, You shall be holy; for I the Lord your God am holy. Exodus 19:6 develops the concept further: And you shall be unto Me a kingdom of priests and a *goi kadosh*, holy nation.

While *kadosh* is generally translated as "holy, sacred," Dr. Bernard J. Bamberger, author of the UAHC commentary on Leviticus, notes that the meaning of "You shall be holy" can be read in the light of the colloquial phrase, "You shall be something special," i.e., set apart. If we substitute "set apart, different" for "holy" or "sacred" in various biblical passages, we derive fresh meanings. For example, the Fourth Commandment enjoins us "to keep [the Shabbat] holy." With the new rendering, it can now read "to keep the Sabbath as a day which is set apart, different." The phrase, *goi kadosh*, could be translated as a "people set apart," that is, a people having a purpose and fate different from those of other peoples. This idea is strengthened in Leviticus 20:26 by the passage: And I have set you apart from other peoples to be Mine.

This interpretation of *kadosh* suggests new ways to look at familiar concepts. For instance, in view of this alternate English rendering, how would you translate *at mekudeshet li*, which the bridegroom says as he places the wedding ring on his bride's finger?

47 גּוֹי קָדוֹשׁ

Hebrew root: ק-ד-שׁ

the Holy One, blessed be He	הַקָּדוֹשׁ בָּרוּךְ הוּא *ha-Kadosh, baruch Hu*
holy nation	*goi kadosh* גּוֹי קָדוֹשׁ
You shall be holy; for I the Lord your God am holy.	קְדשִׁים תִּהְיוּ; כִּי קָדוֹשׁ אֲנִי יְהוָֹה אֱלֹהֵיכֶם. *Kedoshim tiheyu; ki kadosh Ani Adonai Elohechem.*
And you shall be unto Me a kingdom of priests and a holy nation.	וְאַתֶּם תִּהְיוּ לִי מַמְלֶכֶת כֹּהֲנִים וְגוֹי קָדוֹשׁ. *Ve-atem tiheyu Li mamlechet kohanim ve-goi kadosh.*
[generally translated, "holy, sacred"], set apart, different	*kadosh* קָדוֹשׁ
And I have set you apart from other peoples to be Mine.	וָאַבְדִּל אֶתְכֶם מִן הָעַמִּים לִהְיוֹת לִי. *Va-avdil etchem min ha-amim liheyot Li.*

48 Of Prayer and Praying

The new Union prayer book for weekdays, Sabbaths, and festivals is called *Shaarei Tefillah, Gates of Prayer*. The operative word is *tefilah*, prayer. We Jews have an enormous literature of prayer. Among our sacred books are the *siddur*, the traditional prayer book; the *machzor*, the collection of prayers for the *Yamim Nora'im*, the Days of Awe; prayer books for family worship in the home; the *Haggadah*, the Passover narrative and ritual of the *seder;* and Book of Psalms, *Tehilim*. Various prayers of our forebears are recorded throughout the books of the *Tanach*.

Our *tefilot*, prayers, express our deepest yearnings and urgent need to reach out to our Maker. Jews pray directly to God; no intermediary stands between our Creator and ourselves. Most of our prayers are communal. For many reasons— among them, the central fact that God made His *berit*, covenant, with *Benei Yisrael*, the Children of Israel, rather than with one person—we pray to God as a congregation. (Of course, this does not preclude an individual Jew from praying alone.) One example of a communal prayer appears in *Gates of Prayer*, page 42: *Shema kolenu*, Hear our voice, . . . *ki El shome'a tefilot ve-tachanunim Atah*, for You are a God who hears prayer and supplication.

Tefilah is related to the Hebrew root, *pei-lamed-lamed* (the *pei* sometimes changes to *fei*). *Pilel* is the verb meaning to "pray, entreat, judge." A more intensive form of the verb is *hitpalel*, pray, examine oneself, judge oneself. In the *Tanach*, praying occurs for the first time when Abraham prayed, *yitpalel*, to God to cure King Abimelech (Genesis 20:17). The touching story of Hannah in the opening chapters of I Samuel tells how she prayed, *titpalel*, to the Lord for a child.

The noun, *tefilah*, recurs often in the psalms. In Psalm 4:2, for example, David pleads to God: *Shema tefilati!* Hear my prayer! *Tefilah* also appears in the titles of several psalms (e.g., Psalms 86 and 90). Look them up!

48 תְּפִלָּה

Hebrew root: פ-ל-ל

Gates of Prayer	*Shaarei Tefillah* שַׁעֲרֵי תְּפִלָּה
prayer	*tefilah* תְּפִלָּה
prayer book for the Days of Awe	*machzor* מַחֲזוֹר
Book of Psalms	*Tehilim* תְּהִלִּים
prayers	*tefilot* תְּפִלּוֹת

Hear our voice,
for You are a God who hears
prayer and supplication

שְׁמַע קוֹלֵנוּ, *Shema kolenu,*
כִּי אֵל שׁוֹמֵעַ
תְּפִלּוֹת וְתַחֲנוּנִים אָתָּה
ki El shome'a
tefilot ve-tachanunim Atah

pray, entreat, judge	*pilel* פִּלֵּל
pray, examine oneself, judge oneself	*hitpalel* הִתְפַּלֵּל
Hear my prayer!	*Shema tefilati!* שְׁמַע תְּפִלָּתִי!

105

49 Multiple Blessings, Part I

It has been said that a *berachah*, blessing, is a way of *not* taking the world or ourselves for granted, that a *berachah* is a declaration of dependence on God, praising and thanking Him for everything that happens. The fact that we have so many *berachot*, blessings, for virtually every aspect of our lives tells much about our relationship with God.

Baruch, the adjective meaning "blessed, praised," is based on the three-letter Hebrew root, *bet-resh-chaf*, equivalent to *b-r-ch* in English. The same letters also spell *berech*, knee. Scholars see a connection between bending the knee and the act of praising God in ancient Judaism. To this day, most Jews do bow their heads and bend their knees when they reach a certain passage at the conclusion of services: *Va-anachnu korim u-mishtachavim u-modim lifnei Melech malchei ha-melachim*, We therefore bow in awe and thanksgiving before the One who is Sovereign over all. (The text, Hebrew and English, is in *Gates of Prayer*, page 617.)

Our numerous *berachot* begin and sometimes also end with: *Baruch Atah Adonai Elohenu*, Blessed [or praised] is the Lord our God. In the very helpful book, *Bechol Levavcha (With All Your Heart)*, a commentary on the Shabbat morning service, published by the UAHC, Rabbi Harvey J. Fields explains that there are three kinds of *berachot: birchot ha-nehenin*, benedictions of praise in gratitude for the pleasures we derive from eating, drinking, smelling a pleasant aroma, seeing a beautiful sunset or a rainbow; *birchot ha-mitzvot*, benedictions of praise recited when one performs the *mitzvot* commanded in the Torah; and *berachot peratiyot*, benedictions recited at personal or private occasions.

When it was announced in 1966 that S. Y. Agnon, the Hebrew writer, had been awarded the Nobel Prize for Literature, there was speculation about whether or not the ailing author could travel to Stockholm to receive the award from the king of Sweden. Agnon, then 78 years old and known for his great piety, was intent upon going. "There is a special *berachah* one says before a king," he explained, "and I have never met a king." He mustered his strength and went to Stockholm where he at last had the privilege of reciting that "special" *berachah*. In the traditional translation, the *berachah* goes: Blessed art Thou, O Lord our God, King of the universe, who gave of His honor to a human being.

49 בְּרָכוֹת

Hebrew root: ב-ר-ך

blessing, blessings	בְּרָכָה, berachah, בְּרָכוֹת berachot
blessed, praised	בָּרוּך baruch
knee	בֶּרֶך berech

We therefore bow
in awe and thanksgiving
before the One who is Sovereign over all,
the Holy One, blessed be He.

Va-anachnu korim
u-mishtachavim u-modim
lifnei Melech malchei ha-melachim,
ha-Kadosh baruch Hu.

וַאֲנַחְנוּ כּוֹרְעִים
וּמִשְׁתַּחֲוִים וּמוֹדִים
לִפְנֵי מֶלֶךְ מַלְכֵי הַמְּלָכִים
הַקָּדוֹשׁ בָּרוּךְ הוּא.

blessed [or praised] is the Lord our
God

בָּרוּךְ אַתָּה יְיָ אֱלֹהֵינוּ
baruch Atah Adonai Elohenu

benedictions of praise in gratitude for
pleasures granted to mortals

בִּרְכוֹת הַנֶּהֱנִין
birchot ha-nehenin

benedictions of praise recited when
one performs the *mitzvot*

בִּרְכוֹת הַמִּצְוֹת *birchot ha-mitzvot*

benedictions recited at personal or
private occasions

בְּרָכוֹת פְּרָטִיּוֹת *berachot peratiyot*

blessing upon meeting a king:
Blessed art Thou, O Lord our God,
King of the universe,
who gave of His honor to a human
being.

Baruch Atah Adonai Elohenu
Melech ha-olam,
shenatan mikevodo le-vasar va-dam.

בָּרוּךְ אַתָּה יְיָ אֱלֹהֵינוּ
מֶלֶךְ הָעוֹלָם
שֶׁנָּתַן מִכְּבוֹדוֹ לְבָשָׂר וָדָם.

50 Multiple Blessings, Part II

The Hebrew word, *baruch*, blessed, praised, takes many forms, but at the root of it are the constant consonants, *bet-resh-chaf* (*bet* becomes *vet* in some cases). The "Call to [public] Worship" is named the *Barechu*. It is the plural imperative of the verb, "to bless, praise." The full *Barechu* reads: *Barechu et Adonai ha-mevorach*, Praise the Lord, to whom our praise is due. The response by the congregation is: *Baruch Adonai ha-mevorach le-olam va-ed*, Praised be the Lord, to whom our praise is due, now and for ever (see *Gates of Prayer*, page 129). This formula goes back to the fifth century B.C.E. to the days of Ezra and Nehemiah, after the Jews had returned from their Babylonian exile.

Another variation of *baruch* is the word *birkat*, always followed by a specific noun. The *Birkat Shalom*, for instance, is the "Blessing of Peace," which opens: *Sim shalom, tovah, u-verachah*, Grant peace, goodness, and blessing (see *Gates of Prayer*, page 376). Among other well-known blessings are the *Birkat ha-Nerot*, the "Blessing of the Candles"; *Birkat Horim*, the "Parents' Blessing" [of their children]; and the *Birkat ha-Mazon*, the "Blessing [Grace] after Meals."

Still another form of the basic word is *birchot*, benedictions. Some familiar phrases are *Birchot ha-Torah*, the "Blessings of the Torah," and *Birchot ha-Shachar*, the "Morning Benedictions."

In the Jewish lexicon, *Baruch ha-Shem!* is a phrase used by pious Jews to mean "Thank God!" One welcomes a male visitor by saying: *Baruch ha-ba*, Blessed be the one who comes. (The masculine, plural form is *beruchim ha-ba'im*.) For a female visitor, the phrase is *beruchah ha-ba'ah* (plural, *beruchot ha-ba'ot*). Shops in Israel sell tile plaques inscribed *Beruchim ha-Ba'im*, which are popular gifts for friends back home.

50 בְּרָכוֹת

Hebrew root: בּ-ר-ך

"Call to [public] Worship"

בָּרְכוּ Barechu

"Praise the Lord, to whom our praise is due."

בָּרְכוּ אֶת יְיָ הַמְבֹרָךְ.
Barechu et Adonai ha-mevorach.

congregational response to the *Barechu:*
Praised be the Lord, to whom
our praise is due,
now and for ever.

בָּרוּךְ יְיָ הַמְבֹרָךְ
לְעוֹלָם וָעֶד.
Baruch Adonai ha-mevorach
le-olam va-ed.

"Blessing of Peace," which opens:
Grant peace, goodness, and blessing

בִּרְכַּת שָׁלוֹם:
שִׂים שָׁלוֹם, טוֹבָה, וּבְרָכָה
Birkat Shalom:
Sim shalom, tovah, u-verachah

"Blessing of the Candles"

בִּרְכַּת הַנֵּרוֹת Birkat ha-Nerot

"Parents' Blessing" [of their children]

בִּרְכַּת הוֹרִים Birkat Horim

"Blessing [Grace] after Meals"

בִּרְכַּת הַמָּזוֹן Birkat ha-Mazon

"Blessings of the Torah"

בִּרְכוֹת הַתּוֹרָה Birchot ha-Torah

"Morning Benedictions"

בִּרְכוֹת הַשַּׁחַר Birchot ha-Shachar

Thank God!

בָּרוּךְ הַשֵּׁם! Baruch ha-Shem!

Welcome!

בָּרוּךְ הַבָּא Baruch ha-ba (masc.)
בְּרוּכִים הַבָּאִים Beruchim ha-ba'im (masc., pl.)
בְּרוּכָה הַבָּאָה Beruchah ha-ba'ah (fem.)
בְּרוּכוֹת הַבָּאוֹת Beruchot ha-ba'ot (fem., pl.)

51 The Meaning of *Mitzvah*

Of all the words in the Jewish lexicon, perhaps the most abused is the familiar *mitzvah*. First, whenever the word *mitzvah* is translated solely as a "good deed," it is diluted and devitalized. Second, it is often fractured by comedians—Jewish and non-Jewish—who use it as a verb when, in fact, it is a noun. A boy or girl *becomes* a *bar* or *bat mitzvah* or *celebrates* a *bar* or *bat mitzvah;* one simply cannot say: "I was *bar* or *bat mitzvahed* last week." This is like saying: "I was birthdayed last week." *Mitzvah* is a central word in the Jewish lexicon and it should be used respectfully.

Mitzvah is based on the three-letter Hebrew root, *tsadei-vav-hei*. The verb, *tsivah*, means to "command, order, ordain." The noun, *mitzvah*, means "commandment, precept, duty, pious action, kind act." Who does the commanding? In the Jewish tradition, it is God, the Commander, the *Metsaveh*. Orthodox Jews consider themselves bound to carry out all the *mitzvot* (plural) commanded by the *Metsaveh*. Reform Judaism recognizes that individual Jews retain the freedom to choose individual means of response.

In the Jewish tradition, there are 613 *mitzvot* in the Torah. Of these, 365 are prohibitions or negative commandments and 248 are positive mandates. Some are ritualistic; some are moral and ethical (e.g., "You shall love your neighbor as yourself," "You shall not oppress the stranger"). The Central Conference of American Rabbis (CCAR), the association of Reform rabbis, has published a guide to the Jewish life cycle, *Shaarei Mitzvah, Gates of Mitzvah*, which all Reform Jews should ponder.

The phrase, *bar* or *bat mitzvah*, is translated literally as a "son or daughter of the commandment." The phrase specifies the attainment of religious and Jewish legal maturity and, in addition, the occasion at which this status is symbolically assumed. To turn the event into a purely social occasion is to distort its meaning. The *bar* or *bat mitzvah* is a *religious* ceremony that marks the induction of the boy or girl into the ranks of the adult religious community.

51 מִצְוָה

Hebrew root: ה-ו-צ

to command, order, ordain

צִוָּה *tsivah*

commandment, precept, duty, pious action, kind act

מִצְוָה *mitzvah*

[the] Commander, i.e., God

מְצַוֶּה *Metsaveh*

[literally], son of the commandment

בַּר מִצְוָה
bar (Aramaic for "son") *mitzvah*

[literally], daughter of the commandment

בַּת מִצְוָה *bat mitzvah*

the attainment of religious and Jewish legal maturity by a boy or girl; also, the occasion at which this status is symbolically assumed

בַּר מִצְוָה, בַּת מִצְוָה

52 Amen, Amen

The most heart-piercing hymn to survive the Nazi death camps is *Ani Ma-amin*, "I Believe," which countless pious Jews sang on their way to the gas chambers. The Hebrew words originated with Moses Maimonides, the twelfth-century Jewish philosopher, who compiled a list of *Thirteen Articles of Faith*, each beginning with the phrase: *Ani ma'amin be-emunah shelemah*, I believe with perfect [complete] faith. The hymn sung by Jews in the death camps is the twelfth of his thirteen articles: I believe with perfect [complete] faith in the Messiah's coming. And even if he be delayed, I will await him. (The music appears in *Heritage of Music*, by Judith Eisenstein, UAHC, 1972, page 120; the text [English and Hebrew] is in *Gates of Prayer*, page 753.)

The Hebrew noun, *emunah*, is often misunderstood. It is related to the verb, *he'emin*, trust, have confidence, be faithful, steadfast. (*Ma'amin* in the hymn is the present tense of the verb.) *Emunah*, the noun, means "trust, confidence, firmness, reliability, faithfulness." To render *emunah* as "faith, belief " and *he'emin* as to "believe, have faith" is to give them Christian theological overtones that are not present in Judaism. Judaism has no catechism or dogma such as are found in Christianity. The Hebrew Bible nowhere commands Jews to believe in God. It speaks of having trust in Him, of striving to know and understand His ways, of obeying His laws. For these reasons, Moses Mendelssohn, the eighteenth-century philosopher, contended that the Maimonidean formula, *ani ma'amin*, ought to be translated not as "I believe" but rather as "I am firmly convinced."

The core Hebrew letters of *emunah* and *he'emin* are *alef-mem-nun*, equivalent to the English *a-m-n*. The alert reader will immediately notice that these letters spell *Amen*, which means "So be it. It is so." One adjective based on the same root is *ne'eman*, firm, loyal, trustworthy, reliable, faithful. God himself is called *ha-El ha-ne'eman*, the steadfast God (Deuteronomy 7:9). The 1917 English translation of the *Tanach* published by the Jewish Publication Society renders *Ve-he'emin badonai* as "And he [Abraham] believed in the Lord" (Genesis 15:6). The 1962 translation revises the passage to "And . . . he [Abraham] put his trust in the Lord."

A story about *emunah*, confidence, trust, is told about the Chasid who sought advice from his Rebbe because he and his wife were childless:

The Rebbe counseled the Chasid to go home and pray daily and, within a year, a baby would be born. The Chasid did so for a year—then two years, then three, and still no baby. One day the Chasid stopped at an inn. He and the Jewish innkeeper began chatting and very soon the innkeeper confided his sorrow that he and his wife had no children. "My Rebbe assured me that I would have a child," said the Chasid. "Go to see him." The innkeeper went and received the same advice as the Chasid. The next morning, he prayed; then he went to buy a crib.

A year later, the Chasid revisited the inn and was delighted to see a baby lying in the crib. But he was also troubled. He returned to his Rebbe, complaining: "You gave him the same advice you gave me, yet he has a child and I have none."

"Ah," replied the Rebbe, "but he went out and bought a crib!"

52 אָמֵן, אָמֵן

Hebrew root: ן-מ-א

"I Believe,"
title of the famous hymn sung by
Jews in the Nazi death camps

Ani Ma'amin אֲנִי מַאֲמִין

I believe with perfect [complete]
faith . . . ,
the phrase beginning each of Moses
Maimonides's *Thirteen Articles of
Faith*, sometimes translated as "I am
firmly convinced . . ."

אֲנִי מַאֲמִין בֶּאֱמוּנָה שְׁלֵמָה . . .
Ani ma'amin be-emunah shelemah . . .

trust, have confidence, be faithful,
steadfast (verb)

he'emin הֶאֱמִין

trust, confidence, firmness, reliability,
faithfulness

emunah אֱמוּנָה

Amen, so be it, it is so

Amen אָמֵן

firm, loyal, trustworthy, reliable,
faithful

ne'eman נֶאֱמָן

the steadfast God

ha-El ha-ne'eman הָאֵל הַנֶּאֱמָן

And . . . he [Abraham] put his trust
in the Lord.

Ve-he'emin badonai. וְהֶאֱמִן בַּיהוָה.

53 Recognizing Distinctions

Perhaps the most haunting Jewish service conducted in the home is the *Havdalah*, that fragrant and wistful ritual that marks the end of the Shabbat and the festivals. We usher in the Shabbat with the *Kiddush*, and we bid goodbye to it with the *Havdalah*. The twenty-four-hour period between the two is sanctified time. It is as though the *Kiddush* and the *Havdalah* were two dividing lines, with the first separating the Shabbat from the secular time that has just passed, and the second separating the Shabbat from the ordinary workweek that will follow.

Havdalah derives from the Hebrew root, *bet-dalet-lamed* (*bet* frequently changes to *vet*), equivalent to the English *b-d-l* or *v-d-l*. The verb *badal* means to "separate, distinguish, divide." Hence, the noun *havdalah* is translated as "separation, distinction, divison." Actually, *we* are not causing the separating or the dividing. According to our prayer (*Gates of Prayer*, page 635), God is *ha-Mavdil*, He who separates, "sacred from profane, light from darkness, the seventh day of rest from the six days of labor." *We* have created nothing; neither have we caused the elements to separate. What we do at the moment of separation is to marvel at the distinctions and to bless *ha-Mavdil* for His gifts.

Havdalah is a sanctified word. A related Hebrew word, *hevdel*, difference, is secular and can be used in modern Hebrew in an everyday sense: What's the *hevdel*, difference, between this item and that?" In Yiddish, the expression *lehavdl* is used to make a distinction between sacred or noble and profane or evil things mentioned successively, e.g., "Chaim Weizmann used to captivate his audiences and, *lehavdl*, so did Adolf Hitler." What the speaker is saying is that the two ought not to be mentioned in the same breath.

53 הַבְדָּלָה

Hebrew root: ב-ד-ל, ב-ד-ל

ritual service ushering out the Sabbath and the festivals	*Havdalah* הַבְדָּלָה
separate, distinguish, divide	*badal* בָּדַל
separation, distinction, division	*havdalah* הַבְדָּלָה
[God], He who separates	*ha-Mavdil* הַמַּבְדִּיל

prayer at the *Havdalah* service:
Blessed is the Lord our God,
Ruler of the universe,
who separates sacred from profane,
light from darkness,
the seventh day of rest
from the six days of labor.
Blessed is the Lord,
who separates the sacred from the
profane.

בָּרוּךְ אַתָּה, יְיָ אֱלֹהֵינוּ,
מֶלֶךְ הָעוֹלָם,
הַמַּבְדִּיל בֵּין קֹדֶשׁ לְחֹל,
בֵּין אוֹר לְחֹשֶׁךְ,
בֵּין יוֹם הַשְּׁבִיעִי
לְשֵׁשֶׁת יְמֵי הַמַּעֲשֶׂה.
בָּרוּךְ אַתָּה, יְיָ,
הַמַּבְדִּיל בֵּין קֹדֶשׁ לְחֹל.

Baruch Atah, Adonai Elohenu,
Melech ha-olam,
ha-mavdil ben kodesh le-chol,
ben or le-choshech,
ben yom ha-shevi'i
le-sheshet yemei ha-ma'aseh.
Baruch Atah, Adonai,
ha-mavdil ben kodesh le-chol.

difference	*hevdel* הֶבְדֵּל
Yiddish expression used to distinguish between sacred and profane things mentioned successively	*lehavdl* להבדיל*

* Yiddish does not use vowel signs except in rare cases of words which are spelled identically but pronounced differently or are unfamiliar (e.g., proper names, words not in general usage).

54 Turning and Returning

Teshuvah, repentance, is a profound Jewish concept. Genuine *teshuvah,* in the Jewish sense, is an active, soul-searching process, involving far more than a casual "I'm sorry." When a serious wrong has been committed, the offender must acknowledge responsibility, make amends or compensation to the injured party, and secure that person's forgiveness. The offender must resolve never to repeat the wrong; and, finally, the offender must return to the good—the ways of God. *Teshuvah* literally means "return." It is a conscious process, a turning *away from* evil and a returning *to* God. In the Jewish tradition, God will not accept the prayers for forgiveness made by penitents on Yom Kippur unless they have first obtained the forgiveness of those whom they have wronged.

The Jewish conception of *teshuvah* thus holds out hope for those guilty of wrongdoing. As people today recognize, a burden of guilt can at times be so heavy as to paralyze the soul; despair can deaden the will to live. The prophet Ezekiel, speaking the word of the Lord, addressed himself to this problem: If the wicked man repents of all the sins that he committed and keeps all My laws and does what is just and right, he shall live; he shall not die. None of the transgressions he committed shall be remembered against him. . . . Is it My desire that a wicked man shall die?—says the Lord God. It is rather that he shall turn back from his ways and live (Ezekiel 18:21-23).

Teshuvah (plural, *teshuvot*) has still another and more concrete meaning. In the days of the great Babylonian academies (about the sixth to the eleventh centuries of the Common Era), Jews, dispersed throughout the known world, would send questions, *she'elot,* regarding Jewish law to the distinguished scholars, *geonim,* heading those academies. After careful study, the *geonim* sent back—literally, *returned*—answers called *teshuvot.* Through this process of *she'elot u-teshuvot,* questions and responses, there gradually accumulated a body of material called "Responsa Literature." That literature is still growing.

54 תְּשׁוּבָה

Core word: תְּשׁוּבָה

repentance, return	teshuvah	תְּשׁוּבָה
answer or reply	teshuvah	תְּשׁוּבָה
answers or replies	teshuvot	תְּשׁוּבוֹת
question	she'elah	שְׁאֵלָה
questions	she'elot	שְׁאֵלוֹת
"Responsa Literature" [literally, "questions and responses"]	She'elot u-Teshuvot	שְׁאֵלוֹת וּתְשׁוּבוֹת

55 A Plea for Pardon

If you happen to find yourself aboard a crowded bus in Israel, and you inadvertently tread on your neighbor's toe, the courteous thing to say is *selichah*. In this everyday context, it means "I beg your pardon" or "pardon me."

In the context of the synagogue, we also have occasion to plead for *selichah*, forgiveness, and, here, our plea is addressed directly to our Creator. The Jewish conception of God is that of a Supreme Being who hears prayer, who is compassionate and understanding, and who, when the transgressor is genuinely repentant, is forgiving. Notice that no one stands between God and the Jew; all of our prayers, including our *selichot* (prayers for forgiveness), are spoken directly to God. The verb form, *salach*, spelled *samech-lamed-chet*, meaning to "forgive, pardon," is heard frequently, especially before and during the High Holy Days.

The new Union prayer book for the High Holy Days, *Shaarei Teshuvah*, *Gates of Repentance*, contains many *selichot*. On page 252: *Ve-nislach le-chol adat Benei Yisrael ve-lager ha-gar be-tocham, ki le-chol ha-am bi-shegagah*, Knowingly or not, the whole community of Israel and all who live among them have sinned; let them be forgiven; on page 253: *Va-yomer Adonai, "Salachti ki-devarecha,"* And the Lord said, "I have pardoned in response to your plea"; on page 329: *Ve-al kulam, Elo'ah selichot, selach lanu, mechal lanu, kaper lanu*, For all these sins, O God of mercy, forgive us, pardon us, grant us atonement.

We don't wait for the Days of Awe to beg forgiveness of God. In the weekday prayer service (*Gates of Prayer*, page 39), we also beg for *selichah: Selach lanu Avinu ki chatanu*, Forgive us, our Creator, when we have sinned.

55 סְלִיחָה

Hebrew root: ס-ל-ח

I beg your pardon, pardon me	*selichah*	סְלִיחָה
forgiveness, a prayer for forgiveness	*selichah*	סְלִיחָה
forgiveness, prayers for forgiveness	*selichot*	סְלִיחוֹת
forgive, pardon	*salach*	סָלַח

Knowingly or not, the whole community
of Israel and all who live among them have
sinned;
let them be forgiven.

Ve-nislach le-chol adat Benei
Yisrael ve-lager ha-gar be-tocham,
ki le-chol ha-am bi-shegagah.

וְנִסְלַח לְכָל עֲדַת בְּנֵי
יִשְׂרָאֵל וְלַגֵּר הַגָּר בְּתוֹכָם,
כִּי לְכָל הָעָם בִּשְׁגָגָה.

And the Lord said:
"I have pardoned in response to your plea."

Va-yomer Adonai:
"Salachti ki-devarecha."

וַיֹּאמֶר יְיָ:
"סָלַחְתִּי כִּדְבָרֶךָ."

For all these sins, O God of mercy,
forgive us, pardon us,
grant us atonement.

Ve-al kulam, Elo'ah selichot,
selach lanu, mechal lanu,
kaper lanu.

וְעַל כֻּלָם, אֱלוֹהַ סְלִיחוֹת,
סְלַח לָנוּ, מְחַל לָנוּ,
כַּפֶּר לָנוּ.

Forgive us, our Creator, when we
have sinned;
pardon us, our King, when we transgress;
for You are a forgiving God.

Selach lanu Avinu ki chatanu,
mechal lanu Malkenu ki fashanu,
ki mochel ve-sole'ach Atah.

סְלַח לָנוּ אָבִינוּ כִּי חָטָאנוּ,
מְחַל לָנוּ מַלְכֵּנוּ כִּי פָשָׁעְנוּ,
כִּי מוֹחֵל וְסוֹלֵחַ אָתָּה.

56 About Free Will

Throughout history, Judaism has lived with a paradox best defined by the great Rabbi Akiba (c. 40-c. 135 C.E.) in *Pirkei Avot* 3:19: All [everything] is foreseen, but free will [freedom of choice] is given.

Judaism conceives of God as omniscient, omnipresent, and aware of every human action before it occurs. At the same time, Judaism teaches that human beings are endowed with *bechirah chofshit*, free will. In the Jewish view, individuals are responsible for their actions and are accountable to God for their choice of doing either good or evil. Unlike some religions that regard people as helpless victims of an inexorable fate, Judaism sees the human being as capable of discerning between *tov*, good, and *ra*, evil. Early in our history, the *Benei Yisrael* were offered a choice: I have put before you life and death, blessing and curse. Choose life (Deuteronomy 30:19). Earlier (30:15), the choice is described as being between *ha-chayim* and *ha-tov*, life and prosperity, and *ha-mavet* and *ha-ra*, death and adversity.

If God, in the Jewish view, is the source of all good, why is there evil in the world? The answer is complex, but one traditional Jewish answer is that God gave human beings two inclinations: the *yetser ha-tov*, the good instinct, impulse, desire, inclination, and its opposite, the *yetser ha-ra*. The human being is capable of vanquishing the *yetser ha-ra*. Said the Rabbis: Though God created the *yetser ha-ra*, He created [study of] the Law [Torah] as an antidote against it. Some of the Rabbis of the Talmud even professed to see some good in the *yetser ha-ra*, insofar as illicit sexual desire and human competitiveness are two traditional expressions of the evil inclination: If it were not for the *yetser ha-ra*, they observed, man would not build a house, or take a wife, or beget a child, or engage in business.

This Jewish view of the human being is immensely optimistic and liberating. Individuals are not doomed from birth by a relentless destiny. They are capable of growth and of change; they are *perfectible* as are human institutions and society. They have the lifelong ability to perform *teshuvah*, to turn away from *ha-ra* and to choose *ha-chayim* and *ha-tov*.

56 בְּחִירָה חָפְשִׁית

Core words: טוֹב, רָע

free will or choice	בְּחִירָה חָפְשִׁית *bechirah chofshit*
good	טוֹב *tov*
evil	רַע, רָע *ra*
life and prosperity	אֶת הַחַיִּים וְאֶת הַטּוֹב *et ha-chayim ve-et ha-tov*
death and adversity	אֶת הַמָּוֶת וְאֶת הָרָע *et ha-mavet ve-et ha-ra*
instinct, impulse, desire, inclination	יֵצֶר *yetser*
the good inclination	יֵצֶר הַטּוֹב *yetser ha-tov*
the evil inclination	יֵצֶר הָרָע *yetser ha-ra*

Section Five

Jewish Names, Principles, Actions

66. To the Skies!
 aliyah, oleh, olah, El Al, Shir ha-Ma'alot, El Elyon, alah, yarad, yordim, Yarden

67. Let My People Go!
 mishlo'ach manot, shalach, shaliach, shelichut, sheliach tsibur, shalach et ami

68. Builders of Cities and Altars
 banah, binyan, migrash beniyah, boneh, bonim

69. Guards and Guardians
 shomer, shomerim, shamar, Ha-Shomer, shomer Shabbat, matzah shemurah

70. The Time of Singing
 zamir, Shir ha-Shirim, zemirot, shar, shir, shirah

71. Singing Praises
 tehilah, Tehilim, hallel, hillel, Halleluyah

72. Come, Let Us Sing!
 neginah, nigun, ranan, renanah, rinah, ran, ron

57 Hebrews, Israelites, Jews, Part I

No Jewish lexicon can be complete without some understanding of several terms that identify us as individuals and as a people.

The first mention of *Ivri*, Hebrew (plural, *Ivrim*), occurs suddenly in Genesis 14:13 with the phrase, *Avram ha-Ivri*, Abram [Abraham] the Hebrew. The origins of that name are lost in the mists of time. Some scholars conjecture that the name is connected with an ancient people called the "Habiru" who lived in the Fertile Crescent and in Egypt from about the nineteenth to the fourteenth centuries B.C.E. Others note that the Hebrew root-letters of *Ivri—ayin-vet-resh—*are identical with those of *Ever* (or *Eber*), an ancestor of Abram (see Genesis 11:16-26). There is also speculation that *Ivri* may be related to the verb, *avar*, pass or cross over, which, again, is spelled with the same root letters. Abram had to "cross over" the Euphrates River in his journey from Haran to the land of Canaan.

Whatever the derivation of *Ivrim*, Hebrews, according to the Bible scholar, Professor Harry M. Orlinsky, the term, *Yisrael*, Israel, Israelites, replaced *Ivrim* during the period of the Judges (approx. 1200-1000 B.C.E.). The name, *Yisrael*, of course, long antedates the time of the Judges. Genesis 32:29 tells us how Jacob was renamed *Yisrael* after a strange all-night wrestling bout at Peniel with a mysterious figure, a man or perhaps an angel, who informs Jacob at dawn: You have striven, *sarita*, with beings divine [God, *El*, *Elohim*] and human, and have prevailed. This would account for the *s-r* and *El* syllables in *Yisrael*, and the name could be translated as "he who strives with God." In his commentary on Genesis, Rabbi W. Gunther Plaut suggests another possibility: May God rule.

Since that fateful encounter between Jacob and the "man" who may have been an angel, we have identified ourselves as *Benei Yisrael*, the Children of Israel. Notice that the *Shema* declares: *Shema Yisrael*, Hear, O Israel—not *Shema Ivrim*, Hear, O Hebrews.

57 עִבְרִים, בְּנֵי יִשְׂרָאֵל

Core word and Hebrew root: יִשְׂרָאֵל, ע-ב-ר

Hebrew	*Ivri*	עִבְרִי
Hebrews	*Ivrim*	עִבְרִים
Abram [Abraham] the Hebrew	*Avram ha-Ivri*	אַבְרָם הָעִבְרִי
Eber (ancestor of Abram)	*Ever*	עֵבֶר
pass or cross over	*avar*	עָבַר
Israel, Israelites	*Yisrael*	יִשְׂרָאֵל
you have striven	*sarita*	שָׂרִיתָ
God	*El*	אֵל
	Elohim	אֱלֹהִים
he who strives with God, may God rule	*Yisrael*	יִשְׂרָאֵל
Children of Israel	*Benei Yisrael*	בְּנֵי יִשְׂרָאֵל
Hear, O Israel	*Shema Yisrael*	שְׁמַע יִשְׂרָאֵל

58 Hebrews, Israelites, Jews, Part II

The Hebrew term, *Yehudi*, was originally used by members of the tribe of Judah, *Yehudah*, Jacob's fourth son, who, after the conquest of *Erets Yisrael*, settled in the territory called Judah (later, Judea). The tribes joined together to form a united Israelite kingdom under King David and his son, Solomon. But, after Solomon died (about 925 B.C.E.), the kingdom split into two: the northern Kingdom of Israel and the southern Kingdom of Judah. The term, *Yehudi* (plural, *Yehudim*), applied to all those who lived in the southern kingdom. The northern kingdom survived only 200 years before it fell to Assyria (c. 722 B.C.E.). Its people were carried into captivity and disappeared (our *Aseret ha-Shevatim*, Ten Lost Tribes). Those Jews who remained in the Land of Israel thought of themselves as *Benei Yisrael*, the descendants [Children] of Israel. As time went by, they gradually came to be called, especially outside the Land, *Yehudim*, Judeans or Jews.

As we are told by Professor Harry M. Orlinsky, the term "Israelites" was replaced by "Judeans" and "Jews" after the exile in Babylonia (that is, after the year 539 B.C.E., when the Persian king Cyrus issued his proclamation of liberation to the Jewish exiles). The original Hebrew name, *Yehudi*, went through a series of transformations: *Ioudaios* in Greek and *Judaeus* in Latin. Judaism, the religion and way of life of the Jews, came into English via the Greek *Ioudaismos*. In the Book of Esther (5:13), Mordecai is called *ha-Yehudi*, the Jew, and Haman (3:6) threatened to destroy *kol ha-Yehudim*, all the Jews.

In modern Hebrew, there is a single term for "Jewry" and "Judaism": *Yahadut*. Now, as in ancient times, a male Jew is a *Yehudi*; a female is a *Yehudit* or a *Yehudiyah*. The modern "State of Israel" is *Medinat Yisrael*; the "Land of Israel" is *Erets Yisrael*. A male Israeli is a *Yisre-Eli*; a female is a *Yisre-Elit*. We have not been *Ivrim* for at least 3,000 years.

58 יְהוּדִים

Core words: יְהוּדָה, יְהוּדִים

Judah, Jacob's fourth son; the territory of the tribe of Judah	*Yehudah* יְהוּדָה
Judah-ites, Judeans; later, Jews	*Yehudim* יְהוּדִים
descendants [Children] of Israel	*Benei Yisrael* בְּנֵי יִשְׂרָאֵל
Jewry, Judaism	*Yahadut* יַהֲדוּת
Jew or Jewish	*Yehudi* (masc.) יְהוּדִי
	Yehudit, Yehudiyah (fem.) יְהוּדִית, יְהוּדִיָּה
State of Israel	*Medinat Yisrael* מְדִינַת יִשְׂרָאֵל
Land of Israel	*Erets Yisrael* אֶרֶץ יִשְׂרָאֵל
Israeli	*Yisre'eli* [Yisre-Eli] (masc.) יִשְׂרְאֵלִי
	Yisre'elit [Yisre-Elit] (fem.) יִשְׂרְאֵלִית

59 The First Human Being, Part I

By knowing the name of the first human being, Adam, you are well on your way to learning four useful Hebrew words and several expressions. "Adam" is spelled with the Hebrew letters, *alef-dalet-mem*. Besides being a name, *adam* is a noun meaning "man, human being, mankind." The phrase, *ben adam*, means simply "a human being."

Early in *Bereshit* (Genesis 2:7), we discover that God formed *et ha-adam afar min ha-adamah*, man from the dust of the earth. A *midrash* has it that God took the dust from the four corners of the earth so that man would be at home everywhere. Except for a change in the initial vowel sign and the addition of the letter *hei* at the end, *adamah*, earth, soil, ground, is spelled exactly like *adam*. Thus, it is easy to associate *adam* with *adamah*. In his commentary on Genesis, Rabbi W. Gunther Plaut explains that an English equivalent for the paired Hebrew words is: God fashioned [formed] an earthling from the earth. The word *adamah* recurs often in the story of Adam and Eve. When God punishes them for disobeying His first order, He says: By the sweat of your brow shall you get bread to eat, until you return *el ha-adamah*, to the ground (Genesis 3:19).

Cain, the first son of the first family, is an *oved adamah*, a tiller of the soil (Genesis 4:2). He brings an offering to the Lord *mi-peri ha-adamah*, from the fruit of the soil (Genesis 4:3). This leads to the first murder in history. This bloody tale is examined in the next chapter when we learn two more words associated with *adam* and *adamah: dam*, blood, and *adom*, red.

אָדָם 59

Core words: אָדָם, אֲדָמָה

the first human being, Adam, man, human being, mankind	אָדָם *adam*
a human being	בֶּן אָדָם *ben adam*
man from the dust of the earth	אֶת הָאָדָם עָפָר מִן הָאֲדָמָה *et ha-adam afar min ha-adamah*
earth, soil, ground	אֲדָמָה *adamah*
to the ground	אֶל הָאֲדָמָה *el ha-adamah*
tiller of the soil	עוֹבֵד אֲדָמָה *oved adamah*
from the fruit of the soil	מִפְּרִי הָאֲדָמָה *mi-peri ha-adamah*

60 The First Human Being—
Flesh and Blood, Part II

When Adam's son, Cain, killed his younger brother, Abel, God thundered: *Kol demei achicha*, Your brother's blood, cries out to Me *min ha-adamah*, from the ground (Genesis 4:10). The Hebrew word for "blood" is *dam*, spelled *dalet-mem*. The plural is *damim*. *Demei* is a special form of *damim*. *Dam* is an important word. Deuteronomy 12:23-24 and other passages in the Torah absolutely prohibit the eating of animal flesh, *basar*, with the animal's blood, *dam: Ki ha-dam hu ha-nafesh*, For the blood is the life, and you must not consume the life with *ha-basar*, the flesh. The Israelites were horrified at the possibility of eating a live animal. To this day, Orthodox Jewish law requires all meat to be soaked in water and salted before cooking in order to drain out all the blood.

In the famous passage in Leviticus 19:16, we hear more about blood: *Lo ta-amod al dam re'echa*, You shall not stand idly by the blood of your neighbor.

King David was forbidden to build the Temple in Jerusalem. As explained in I Chronicles 22:8, God told David: You have shed *dam larov*, blood abundantly . . . ; you shall not build a house to My name, because you have shed *damim rabim* (plural), much blood. The great task was therefore passed to David's son, Solomon, a man with clean hands.

Basar va-dam, flesh and blood, is a familiar expression in Hebrew. (In Yiddish, it is *boser ve-dom*.) A person who says "I am only a creature of *basar va-dam*," means: I am only a mortal with mortal failings.

From *dam*, blood, to *adom*, red, is a natural progression. Esau, a *ben adam* who roamed the *adamah*, sold his precious birthright to Jacob for a taste of *ha-adom, ha-adom ha-zeh*, this red, red pottage (Genesis 25:30). In that same passage, we learn that his craving for *ha-adom* was the reason he was later called *Edom*, that is, the ancestor of the people of Edom, the land southeast of what is now Jordan.

60 אָדָם, בָּשָׂר וָדָם

Core words: דָּם, אָדֹם

your brother's blood

[קוֹל] דְּמֵי אָחִיךָ
[kol] demei achicha

from the ground

min ha-adamah מִן הָאֲדָמָה

blood

dam דָּם
damim (pl.) דָּמִים

animal flesh

basar בָּשָׂר

for the blood is the life

כִּי הַדָּם הוּא הַנָּפֶשׁ
ki ha-dam hu ha-nafesh

You shall not stand idly by the blood of your neighbor.

לֹא תַעֲמֹד עַל דַּם רֵעֶךָ.
Lo ta'amod al dam re'echa.

blood abundantly

dam larov דָּם לָרֹב

much blood

damim rabim דָּמִים רַבִּים

flesh and blood (i.e., mortal)

basar va-dam בָּשָׂר וָדָם

red

adom אָדֹם

this red, red pottage

הָאָדֹם, הָאָדֹם הַזֶּה
ha-adom, ha-adom ha-zeh

a name for Esau, showing the ancient relationship between the Hebrews and the people of Edom

Edom אֱדוֹם

61 The Importance of Names, Part I

Our *Tanach* records hundreds of personal *shemot*, names (singular, *shem*). The ancients—like many moderns today—were intensely concerned to know exactly who they and their ancestors were. The list of "begots" in the *Tanach* are testimony to their preoccupation with genealogy. Further, they took great care to record and often explain the names of things and places around them. Very soon after the Creation, Adam had the assignment of giving *shemot* to all the animals and birds (Genesis 2:19-20), a prodigious performance considering his youth and inexperience.

The second book of our *Torah*, Exodus, is *Shemot*, "Names," in Hebrew, from the opening phrase of that book, *Ve-eleh shemot*, These are the names. The text goes on to name the *Benei Yisrael*, the Children of Israel, who went down with him to Egypt. But, before we reach *Shemot*, we must return to *Bereshit* which is packed with episodes having to do with *shemot*. For instance, two of the Three Patriarchs and one of the Four Matriarchs are given new names at important junctures in their lives. Abram at 99 becomes Abraham, father of a multitude of nations, when God announces His covenant with him (Genesis 17); and Sarai at 90 becomes *Sarah*, princess. Abraham's grandson Jacob undergoes a dramatic change of *shem* at Peniel (Genesis 32:25-31) just as he is about to return to the land of Canaan after twenty years of service with Laban, his uncle and father-in-law, in Haran. Name-changing apparently symbolized a change in status or personality.

Throughout *Bereshit*, important *shemot* are explained in the text. Sarah laughs (the Hebrew verb *tsachak* means to "laugh") when she learns she will bear a child in her old age (Genesis 18:12), and this laughter is incorporated into the name of her son, Isaac, *Yitschak*. In vivid contrast, Isaac's grandson, Benjamin, is originally named *Ben oni*, son of my suffering [strength], by his dying mother, Rachel (Genesis 35:18), but the grieving Jacob renames him Benjamin. In his commentary on *Bereshit*, Rabbi W. Gunther Plaut reviews the range of interpretations of the name, Benjamin. *Ben yamin* can mean "son of the south" or "son of the right hand," that is, the favored side. *Ben yamim* yields the poignant "son of old age."

שְׁמוֹת 61

Core words: שֵׁם, שְׁמוֹת

name	shem שֵׁם
names	shemot שְׁמוֹת
Book of Exodus	Shemot שְׁמוֹת
these are the names	ve-eleh shemot וְאֵלֶּה שְׁמוֹת
father of a multitude of nations	Av-raham אַבְרָהָם
princess	Sarah שָׂרָה
laugh (verb)	tsachak צָחַק
Isaac	Yitschak יִצְחָק
son of my suffering [strength]	ben oni בֶּן אוֹנִי
Benjamin	Binyamin בִּנְיָמִין
son of the south or son of the right hand (i.e., favored)	ben yamin בֶּן יָמִין
son of old age	ben yamim בֶּן יָמִים

133

62 The Importance of Names, Part II

Our *Tanach* very carefully records the *shemot* of our ancestors, often explaining their meanings. When it comes to the *Shem* of our Creator, however, the *Tanach* is unclear. Common sense tells us that this absence of clarity is wise, for once we give a name to something [or someone] the object loses part of its mystery. We've put a permanent handle on it (and it is no accident that "handle" happens to be American slang for "name").

The God of Israel is forever unique, invisible, and unknowable. We sometimes refer to Him as *Ha-Shem*, *The* Name. Of one thing we are certain: the *Shem* of *Ha-Shem* is *not* "Jehovah." As Rabbi W. Gunther Plaut tells us in his commentary on *Bereshit*, a sixteenth-century Christian writer, unaware of Jewish custom, misunderstood the vowel signs in the four-letter symbol of God's *Shem* and transliterated the Hebrew symbol as "Jehovah." His error has been perpetuated ever since.

In the episode of the burning bush (Exodus 3:1-13), Moses tries to ascertain God's name, on the grounds that the Israelites will ask him: *Mah Shemo?* What is His name? In the confusing passage that follows (Exodus 3:14-15), we find the Tetragrammaton, that is, the four-letter name of God, consisting of the Hebrew letters, *yod-hei-vav-hei*, sometimes printed as YHWH or YHVH. We Jews never pronounce either the Tetragrammaton or the double-*yod* symbol of His name. Indeed, even if we wished to, we no longer know the pronunciation. The *Shem* was so holy that, in the days of the Temple, only the High Priest had the authority to voice it, and on only one day of the year, *Yom Kippur*. With the destruction of the Temple, the knowledge of the pronunciation disappeared. Our custom traditionally has been to superimpose the vowel signs belonging to the word *Adonai*, "my Lord," upon the Tetragrammaton. Whenever we come to the Tetragrammaton and the double-*yod* symbol in the Torah and the prayer book, we read them aloud as "*Adonai.*"

God has other *shemot: Elohim*, God, and *El*, found in such terms as *El Shaddai*, God Almighty, and *El Elyon*, God Most High. We meet Him also in such phrases as *Ribono shel olam*, Master of the universe; *im yirtseh ha-Shem*, God willing; *Adon olam*, eternal Lord; and *Adonai Elohenu*, the Lord our God.

Core words: שֵׁם, הַשֵּׁם

The Name (of God)	*Ha-Shem* הַשֵּׁם
What is His name?	*Mah Shemo?* מַה שְׁמוֹ?
Tetragrammaton	*yod-hei-vav-hei* (never pronounced) י-ה-ו-ה
Tetragrammaton with the vowel signs of the word "Adonai"	pronounced *Adonai* יְהֹוָה
double-*yod* symbol of God's name	pronounced *Adonai* יְיָ
my Lord	*Adonai* אֲדֹנָי
God	*Elohim* אֱלֹהִים
	El אֵל
God Almighty	*El Shaddai* אֵל שַׁדַּי
God Most High	*El Elyon* אֵל עֶלְיוֹן
Master of the universe	רִבּוֹנוֹ שֶׁל עוֹלָם *Ribono shel olam*
God willing	אִם יִרְצֶה הַשֵּׁם *im yirtseh ha-Shem*
eternal Lord	*Adon olam* אֲדוֹן עוֹלָם
the Lord our God	*Adonai Elohenu* יְיָ אֱלֹהֵינוּ

63 Soul Language

One of the cardinal Jewish teachings is the principle of *piku'ach nefesh*, the saving of life. The obligation to save life takes precedence over nearly all Jewish laws. For example, the laws prohibiting work on the Shabbat in traditional Judaism not only may be set aside but they *must* be set aside for *piku'ach nefesh*. Similarly, the laws ordaining a strict fast on Yom Kippur must also be set aside when fasting endangers human life.

The word *nefesh*, soul, spirit of life, person, appears in a number of familiar phrases. In the weeks before the High Holy Days, Jews traditionally engage in *cheshbon ha-nefesh*, soul-searching, spiritual stocktaking. To ask forgiveness, Jews must probe their souls and make an honest appraisal of all their sins of omission and commission. The word *cheshbon*, reckoning, account, bill, invoice, is an everyday word when used alone. (In modern Israel, you ask the waiter for a *cheshbon* at the end of your meal.) When *cheshbon* is paired with *ha-nefesh*, the soul, it denotes a spiritual process.

Nefesh is also paired with the adjective, *chayah*, to mean a "living being" or "living creature." You will find the phrase used in Genesis 1:20, 1:24, and 2:19 to mean "living creature." Genesis 2:7 describes how God formed man and blew into his nostrils the breath of life, and man became a *nefesh chayah*, a living being. Immediately after reciting the *Shema*, we read the passage: And you shall [must] love the Lord your God with all your heart *u-ve-chol nafshecha*, and with all your soul (Deuteronomy 6:5). In I Samuel 18:1, the friendship between Jonathan and David was so close that the *nefesh Yehonatan*, soul of Jonathan, was bound up *be-nefesh David*, with the soul of David.

Two other words sometimes substituted for *nefesh* are *ru'ach*, wind, air, breath, soul, spirit, and *neshamah*, soul, spirit. Genesis 6:17 uses the phrase *ru'ach chayim* as "breath of life"; Genesis 1:30 uses *nefesh chayah* as "breath of life." In our daily morning prayer (*Gates of Prayer*, page 53), we thank God for the *neshamah*, soul, He has given us. It is a *neshamah tehorah*, a pure soul.

נֶפֶשׁ 63

Core words: נֶפֶשׁ, נְשָׁמָה, רוּחַ

saving of life	piku'ach nefesh	פִּקוּחַ נֶפֶשׁ
soul, spirit of life, person	nefesh	נֶפֶשׁ
soul-searching, spiritual stocktaking	cheshbon ha-nefesh	חֶשְׁבּוֹן הַנֶּפֶשׁ
reckoning, account, bill, invoice	cheshbon	חֶשְׁבּוֹן
living being, breath of life	nefesh chayah	נֶפֶשׁ חַיָּה
and with all your soul	u-ve-chol nafshecha	וּבְכָל נַפְשְׁךָ
wind, air, breath, soul, spirit	ru'ach	רוּחַ
soul, spirit	neshamah	נְשָׁמָה
breath of life	ru'ach chayim	רוּחַ חַיִּים
pure soul	neshamah tehorah	נְשָׁמָה טְהוֹרָה

64 The Principle of Action

Judaism stresses action over passivity, the doing of deeds over the mere contemplation of them. It is not surprising that the Hebrew verb *asah*, spelled *ayin-sin-hei*, meaning to "do, make," should appear over 1,200 times in our Hebrew Bible. When the Hebrew verb becomes a noun form like *oseh*, the doing, the doer, the maker, and *ma'aseh*, meaning "work, deed, story," you will find at least another thousand uses of the word that emphasizes the principle of action.

In the opening chapter of *Bereshit*, we read that "God made the expanse, *va-ya'as Elohim et ha-rakia*" (1:7), and later "God made wild beasts . . . , *va-ya'as Elohim et chayat ha-arets*" (1:25); and after that He said: Let us make man in our image, *Na'aseh adam be-tsalmenu* (1:26). On the sixth day, God saw "all that He had made, *et kol asher asah* (1:31), and found it *tov me'od*." Psalm 121:2 celebrates the Lord who "made heaven and earth, *oseh shamayim va-arets*." The reverberating phrase, the "work of creation," is called *ma'aseh vereshit*.

On virtually every page of the prayer book, one comes upon passages using the verb *asah* in various forms and also the noun *oseh*, the Maker. In *Gates of Prayer*, page 55, is the exclamatory passage: *Mah rabu ma'asecha, Adonai; kulam be-chochmah asita*, How manifold are Your works, O Lord; in wisdom You have made them all. On page 59, God is praised for "*oseh fele*, [the] doing [of] wonders." And, on page 71 (and on many other pages as well), there is the soaring prayer: *Oseh shalom bi-meromav, Hu ya'aseh shalom alenu ve-al kol Yisrael*, May He who causes peace to reign in the high heavens let peace descend on us and on all Israel.

עָשָׂה 64

Hebrew root: ה-שׂ-ע

do, make *asah* עָשָׂה

(the) doing, (the) doer, (the) maker *oseh* עוֹשֶׂה

work, deed, story *ma'aseh* מַעֲשֶׂה

and God made the expanse

וַיַּעַשׂ אֱלֹהִים אֶת הָרָקִיעַ
va-ya'as Elohim et ha-rakia

and God made wild beasts . . .

וַיַּעַשׂ אֱלֹהִים אֶת חַיַּת הָאָרֶץ
va-ya'as Elohim et chayat ha-arets

Let us make man in our image.

נַעֲשֶׂה אָדָם בְּצַלְמֵנוּ.
Na'aseh adam be-tsalmenu.

all that He had made *et kol asher asah* אֶת כָּל אֲשֶׁר עָשָׂה

very good *tov me'od* טוֹב מְאֹד

made heaven and earth *oseh shamayim va-arets* עֹשֶׂה שָׁמַיִם וָאָרֶץ

work of creation *ma'aseh vereshit* מַעֲשֵׂה בְרֵאשִׁית

How manifold are Your works, O Lord!

מָה רַבּוּ מַעֲשֶׂיךָ, יְיָ!
Mah rabu ma'asecha, Adonai!

In wisdom You have made them all.

כֻּלָּם בְּחָכְמָה עָשִׂיתָ.
Kulam be-chochmah asita.

[the] doing [of] wonders *oseh fele* עֹשֶׂה פֶּלֶא

[May He who] causes peace to reign in the high heavens

עֹשֶׂה שָׁלוֹם בִּמְרוֹמָיו
Oseh shalom bi-meromav

[May] He let peace descend on us and on all Israel.

הוּא יַעֲשֶׂה שָׁלוֹם עָלֵינוּ
וְעַל כָּל יִשְׂרָאֵל.
Hu ya'aseh shalom alenu
ve-al kol Yisrael.

65 Deeds, Actions, Stories

The performance of deeds is so important in Judaism that the verb *asah*, to do, make, cause, bring about, perform, accomplish, and the noun forms, *oseh* and *ma'aseh*, are high-frequency words in Jewish literature. In *Pirkei Avot*, you will find aphorisms emphasizing the necessity to act: The sage Shammai taught (1:15): *Emor me'at va-aseh harbeh*, Say little and do much, which is the forerunner of "Actions speak louder than words." Rabbi Jacob said (4:22): Better one hour of repentance, *teshuvah*, and good works, *ma'asim tovim*, in this world than all the life of the world-to-come, *ha-olam ha-ba*.

Ma'aseh (plural, *ma'asim*) is an omnibus word with many meanings: deed, action, work, occupation, fact, event, tale, story. It is heavily used in Hebrew, but many American Jews know it better perhaps in the Yiddish usage, as *mayse*, story, tale, or *bobe mayse*, an expression often taken to mean a "tall story, fairy tale, grandmother's tale." The origin of the Yiddish term, *bobe mayse*, is disputed. Yiddish scholars speculate that *bobe mayse* may be a corruption of *bovo mayse*, that is, a tale from the book, *Bovo d'Antona*, a collection of Yiddish stories recounting the adventures of a fictional medieval knight named Prince Bovo of Antona. Elijah Levitas, a Hebrew teacher and scholar (1468-1549), adapted the story of Prince Bovo from the Italian version of a medieval English tale called *Bevys of Hampton*. Levitas retold Bovo's adventures and deeds of derring-do in rhymed Yiddish form. The book was enormously popular among Yiddish readers in Europe for centuries. The Yiddish-speaking medieval knight, Prince Bovo, is a stalwart romantic hero who is, of course, Jewish in the Levitas adaptation. Bovo's ladylove is the fair Princess Druzana who is, of course, Jewish also and naturally speaks a fluent Yiddish.

65 מַעֲשִׂים

Hebrew root: ע-שׂ-ה

do, make, cause, bring about, perform, accomplish	עָשָׂה *asah*
Say little and do much.	אֱמֹר מְעַט וַעֲשֵׂה הַרְבֵּה. *Emor me'at va-aseh harbeh.*
good works	מַעֲשִׂים טוֹבִים *ma'asim tovim*
the world-to-come	הָעוֹלָם הַבָּא *ha-olam ha-ba*
deed, action, work, occupation, fact, event, tale, story	מַעֲשֶׂה *ma'aseh* מַעֲשִׂים *ma'asim* (pl.)
story, tale	*mayse* (Yiddish) מעשׂה*
tall story, fairy tale, grandmother's tale	*bobe mayse* (Yiddish) באָבע מעשׂה*
Bovo of Antona	*Bovo d'Antona* (Yiddish) בָּבָא דְאַנְטוֹנָה*
tale of Bovo	*bovo mayse* (Yiddish) בָּבָא מעשׂה*

* See footnote, chapter 53.

66 To the Skies!

It is a great honor for a Jew to receive an *aliyah*, that is, to be called up to the *bimah* for the reading of the Torah. The *bimah*, pulpit, is an elevated platform, a stage. To reach it, one must ascend stairs. Hence the noun, *aliyah*, which means "ascent, rise, going up."

The same word, *aliyah*, is also used in the sense of immigrating to the State of Israel. Jews go there "on *aliyah*," or they "make *aliyah*." Moving to Israel is always an "ascent" on the part of the incoming *oleh* (feminine, *olah*). The fastest way for *olim*, immigrants, to ascend to Israel is by plane. The name of the Israeli airline, *El Al*, literally means "to the height" or "to the skies."

Some of our psalms (see Psalms 120-134) open with the phrase: *Shir ha-Ma'alot* (the final syllable rhymes with "boat"), Song of Ascents. Scholars believe that these songs were sung by Jews as they made their "pilgrimage on foot," *aliyah le-regel*, up the winding roads to the Temple in Jerusalem on the Three Pilgrim Festivals each year (see chapter 41). It is also possible that, in ancient times, the Levites recited a *Shir ha-Ma'alot* as they ascended the steps of the Temple. Their songs were praises of *El Elyon*, God Most High.

Jews always "ascend" to the Land of Israel. The verb is *alah*, spelled *ayin-lamed-hei*. Jews never "leave" the Land; they "descend" from it, and the verb for "go down, come down, emigrate from Israel" is *yarad*. Emigrants are called *yordim*. The Jordan River is the *Yarden*, the river that descends from the heights of Mount Hermon in the north to the lowest spot on earth, the Dead Sea.

The dream of Jacob during his journey to Haran (Genesis 28:12) is one of the magnificent episodes in the Torah and in world literature. He dreams of a stairway or ladder reaching from the earth up to the heaven, with angels of the Lord *olim ve-yordim*, ascending and descending, on it.

66 אֶל עָל!

Hebrew roots: ע-ל-ה, י-ר-ד

pulpit, elevated platform, stage	*bimah* בִּימָה
ascent, rise, going up	*aliyah* עֲלִיָּה
immigration to Israel	*aliyah* עֲלִיָּה
immigrant	*oleh* (masc.) עוֹלֶה
immigrants	*olim* (masc.) עוֹלִים
immigrant	*olah* (fem.) עוֹלָה
immigrants	*olot* (fem.) עוֹלוֹת
to the height, to the skies	*El Al* אֶל עָל
Song of Ascents	*Shir ha-Ma'alot* שִׁיר הַמַּעֲלוֹת
pilgrimage on foot to Jerusalem	*aliyah le-regel* עֲלִיָּה לְרֶגֶל
God Most High	*El Elyon* אֶל עֶלְיוֹן
ascend, rise, go up, immigrate to Israel	*alah* עָלָה
descend, go down, come down, emigrate from Israel	*yarad* יָרַד
emigrant	*yored* (masc.) יוֹרֵד
emigrants	*yordim* (masc.) יוֹרְדִים
emigrant	*yoredet* (fem.) יוֹרֶדֶת
emigrants	*yordot* (fem.) יוֹרְדוֹת
Jordan River	*Yarden* יַרְדֵּן
ascending and descending	*olim ve-yordim* עֹלִים וְיֹרְדִים

67 Let My People Go!

Purim is a holiday for merrymaking *u-mishlo'ach manot*, and sending gifts (Esther 9:19). The phrase for "sending gifts" is better known to many American Jews in Yiddish, *shalakh mones*. Actually, *manot* means "portions." This explains the Purim custom of sending portions of cakes and *hamantashen* to friends and neighbors.

The Hebrew verb, *shalach*, meaning to "send, extend, send away, dismiss," is spelled *shin-lamed-chet*. From this same root, we derive such nouns as *shaliach*, emissary, envoy, messenger; *shelichut*, errand, mission; and the Hebrew title of the cantor, *sheliach tsibur*, literally, "messenger of the congregation," who leads the congregation in prayer.

The verb *shalach* is heavily used in the *Tanach*, often very dramatically. And [Noah] sent forth the dove, *va-yeshalach et ha-yonah* (Genesis 8:8), to learn if the Flood had abated. The story of King David and Uriah the Hittite (II Samuel 11) uses *shalach* as a death knell. David had fallen in love with Bathsheba, had taken her, and learned that she was pregnant by him. As David knew, she was the wife of Uriah the Hittite who, at the moment, was away fighting one of David's wars. David recalled Uriah and ordered him to go home to his wife—a device to make Uriah believe later that the child was his. But it didn't work: Uriah refused to go home. And so David plotted to get rid of Uriah: He wrote a letter to his general, Joab, *va-yishlach be-yad Uriah*, and sent it by the hand of Uriah. The letter was David's order to Joab to place Uriah in the front lines where he would be killed. Unwitting Uriah was the *shaliach*, messenger, of his own death warrant. To be sure, David, Bathsheba, and the child all suffered later for David's sin.

Nowhere in the *Tanach* is *shalach* used more powerfully than in the Book of Exodus (chapters 5-10) when, repeatedly and with mounting urgency, Moses and Aaron confront Pharaoh with the same insistent message from the Lord: *Shalach et ami*, Let My people go. In the end, Pharaoh has to yield.

Today, we pray that the same message, *Shalach et ami*, will have the same effect on the Soviet leaders who are denying the right of Soviet Jews to emigrate.

67 שַׁלַּח אֶת עַמִּי!

Hebrew root: ש-ל-ח

sending [Purim] gifts	*mishlo'ach manot* מִשְׁלֹחַ מָנוֹת
portion, ration	*manah* מָנָה
portions, rations	*manot* מָנוֹת
send, extend, send away, dismiss	*shalach* שָׁלַח
emissary, envoy, messenger	*shaliach* שָׁלִיחַ
errand, mission	*shelichut* שְׁלִיחוּת
cantor: messenger of the congregation	*sheliach tsibur* שְׁלִיחַ צִבּוּר
and [Noah] sent forth the dove	וַיְשַׁלַּח אֶת הַיּוֹנָה *va-yeshalach et ha-yonah*
and sent it by the hand of Uriah	וַיִּשְׁלַח בְּיַד אוּרִיָּה *va-yishlach be-yad Uriah*
Let My people go!	שַׁלַּח אֶת עַמִּי! *Shalach et ami!*

68 Builders of Cities and Altars

For those who think of early biblical personalities primarily as simple nomads, it is a revelation to consider how much building went on in ancient times. For instance, Cain *boneh ir*, built a city, and named it after his son Enoch (Genesis 4:17). And [Noah] built an altar, *va-yiven mizbe'ach*, to God after the Flood (Genesis 8:20). His descendants said to one another: *Havah, nivneh lanu ir*, Come, let us build us a city (Genesis 11:4). Once the patriarchs appear on the scene, they begin to build altars to God. "And Abraham built the altar there, *va-yiven sham Avraham et ha-mizbe'ach*" on Mount Moriah (Genesis 22:9). During their enslavement in Egypt, the Children of Israel *yiven arei miskenot le-Faroh et Pitom ve-et Ra'amses*, they built for Pharaoh store-cities [garrison cities], Pithom and Raamses (Exodus 1:11).

The word common to all the Hebrew passages is the verb *banah*, spelled *bet-nun-hei* (at times, *bet* becomes *vet*). The verb means to "build, build up, erect." By changing vowel signs and dropping or adding consonants, the verb *banah* can become the noun *binyan*, meaning a "building, structure." A "building plot, lot, site" in modern Hebrew is a *migrash beniyah*. A "builder" is *boneh*. The supreme *boneh* in the *Tanach* is Solomon who spent seven years building the Temple; immediately after this, we learn: *Ve-et beto banah Shelomoh shelosh esreh shanah*, And Solomon was building his own house [for] thirteen years (I Kings 7:1).

Gates of Prayer contains several illustrations of *banah* in various forms. The famous passage from Psalm 118:22, for example, appears on page 529: *Even ma'asu ha-bonim haitah le-rosh pinnah*, The stone the builders rejected has become the chief cornerstone. (Rosh Pinnah is the name of a town in northern Israel founded in 1878.) On pages 592-593, the final line of the song, *Yerushalayim*, is quoted: Jerusalem, O Jerusalem! Out of your ruins will I *evnech*, rebuild you.

Hebrew root: ב-נ-ה

build, build up, erect	banah בָּנָה
he [Cain] built a city	boneh ir בֹּנֶה עִיר
altar	mizbe'ach מִזְבֵּחַ
and [Noah] built an altar	va-yiven mizbe'ach וַיִּבֶן מִזְבֵּחַ
Come, let us build us a city.	הָבָה, נִבְנֶה לָנוּ עִיר. *Havah, nivneh lanu ir.*
And Abraham built the altar there.	וַיִּבֶן שָׁם אַבְרָהָם אֶת הַמִּזְבֵּחַ. *Va-yiven sham Avraham et ha-mizbe'ach.*
And they [the Children of Israel] built for Pharaoh store-cities [garrison cities], Pithom and Raamses.	וַיִּבֶן עָרֵי מִסְכְּנוֹת לְפַרְעֹה אֶת פִּתֹם וְאֶת רַעַמְסֵס. *Va-yiven arei miskenot le-Faroh et Pitom ve-et Ra'amses.*
building, structure	binyan בִּנְיָן
building plot, lot, site	migrash beniyah מִגְרָשׁ בְּנִיָּה
builder, builders	bonim בּוֹנִים, boneh בּוֹנֶה
And Solomon was building his own house [for] thirteen years.	וְאֶת בֵּיתוֹ בָּנָה שְׁלֹמֹה שְׁלֹשׁ עֶשְׂרֵה שָׁנָה. *Ve-et beto banah Shelomoh shelosh esreh shanah.*
The stone the builders rejected has become the chief cornerstone.	אֶבֶן מָאֲסוּ הַבּוֹנִים הָיְתָה לְרֹאשׁ פִּנָּה. *Even ma'asu ha-bonim haitah le-rosh pinnah.*
I will rebuild you	evnech אֶבְנֵךְ

69 Guards and Guardians

Like the English word, "guard," the Hebrew equivalent, *shomer,* can be used in several ways. As a noun, *shomer* is a "guard, keeper, watchman." The three-letter Hebrew root, *shin-mem-resh*—the sounds *sh-m-r* in English—spell *shamar,* the verb which means to "keep, watch, guard, preserve, retain" and even to "observe, celebrate." One of the most famous quotations in history is Cain's reply to God's question in Genesis 4:9: Where is your brother Abel? Cain answered: *Lo yadati,* I do not know. *Ha-shomer achi anochi?* Am I my brother's keeper? Another famous quotation appears in Isaiah 21:11: *Shomer, mah mi-lailah?* Watchman, what of the night?

Police officers are, of course, guards and protectors. In this country, the local associations of Jewish police officers sometimes call themselves *Shomerim* Societies. In 1905, fifteen years before the formation of the Haganah, Israel's pre-State underground army, Jewish settlers established *Ha-Shomer* (literally, "The Guard"), a network of young Jews who took responsibility for watching over Jewish farms and settlements. A Jew who guards or preserves or observes the sanctity of the *Shabbat* is called a *shomer Shabbat* (feminine, *shomeret Shabbat*). During Pesach, ultra-pious Jews will not eat mass-produced holiday *matzah.* Instead they seek out *matzah shemurah,* guarded *matzah,* that has literally been "watched" by strictly observant Jews from the moment of the wheat harvest through every step of the hand-baking process.

The Shabbat is so important that the Lord himself commands Moses to tell the people to keep the day (Exodus 31:16). A portion of that passage, *Ve-shameru,* sung in the Shabbat evening service in the synagogue (*Gates of Prayer,* page 133), opens: *Ve-shameru venei Yisrael et ha-Shabbat,* And the people of Israel shall keep the Sabbath.

שׁוֹמֵר 69

Hebrew root: שׁ-מ-ר

guard, keeper, watchman	שׁוֹמֵר *shomer*
guards, keepers, watchmen	שׁוֹמְרִים *shomerim*
keep, watch, guard, preserve, retain; observe, celebrate	שָׁמַר *shamar*

Am I my brother's keeper?

*הֲשֹׁמֵר אָחִי אָנֹכִי?
Ha-shomer achi anochi?

Watchman, what of the night?

*שֹׁמֵר, מַה מִלַּיְלָה?
Shomer, mah mi-lailah?

"The Guard" (in pre-State Israel)

הַשׁוֹמֵר *Ha-Shomer*

Sabbath observer

שׁוֹמֵר שַׁבָּת *shomer Shabbat* (masc.)
שׁוֹמֶרֶת שַׁבָּת *shomeret Shabbat* (fem.)

guarded *matzah*

מַצָּה שְׁמוּרָה *matzah shemurah*

And the people of Israel shall keep the Sabbath.

וְשָׁמְרוּ בְנֵי יִשְׂרָאֵל
אֶת הַשַּׁבָּת.
*Ve-shameru venei Yisrael
et ha-Shabbat.*

* The *Tanach* omits the vav in the word שׁוֹמֵר.

70 The Time of Singing

Isaac Bashevis Singer, the Nobel Laureate, has a son who is a journalist in Israel. The son's name, fittingly enough, is Zamir, Hebrew for "singing" or "nightingale." In *Shir ha-Shirim*, The Song of Songs, 2:11-12, the word appears in a beautiful lyrical passage: For, lo, the winter is past, / The rain is over and gone; / The flowers appear on the earth; / *Et ha-zamir*, The time of singing, is come.

Had young Zamir wanted an exact equivalent of "singer," he could have chosen *zamar* (feminine, *zameret*). The Hebrew infinitive meaning "to sing, play a musical instrument" is *le-zamer*. The three-letter Hebrew root, *zayin-mem-resh*, is at the core of such musical words as *zemer*, song, tune, and *zemirah*, hymn. The plural of *zemirah* is *zemirot*, widely used to mean Sabbath songs and hymns, those sung around the table after the Shabbat and festival meals.

A second and more familiar Hebrew verb meaning to "sing" is *shar*, spelled *shin-resh*. The noun meaning a "song, poem" is *shir* or *shirah*. We met this word in *Shir ha-Shirim* and also in *Shir ha-Ma'alot*, Song of Ascents (chapter 66). From the mass of evidence in the *Tanach*, we know that the Children of Israel were a singing people, ready to burst into song at moments of high emotion. For example, Moses and the Children of Israel sang a *shirah* of exultation after they had crossed the Sea of Reeds (Exodus 15:1 ff). The prophetess Deborah is celebrated for her song in Judges 5.

The book that contains the largest number of *shirim* is, of course, Psalms, which is examined in the next chapter. Many of the psalms are attributed to the "sweet singer of Israel," David. Over and over, we find in these *shirim* (e.g. Psalm 96) the line: *Shiru ladonai shir chadash*, O sing unto the Lord a new song. The phrase always seems to explode like joyous fireworks.

70 עֵת הַזָּמִיר

Hebrew roots: ז-מ-ר, שׁ-ר

singing, nightingale	זָמִיר *zamir*
The Song of Songs	*Shir ha-Shirim* שִׁיר הַשִּׁירִים
the time of singing	*et ha-zamir* עֵת הַזָּמִיר
singer	*zamar* (masc.) זַמָּר
	zameret (fem.) זַמֶּרֶת
to sing, to play a musical instrument	*le-zamer* לְזַמֵּר
song, tune	*zemer* זֶמֶר
hymn	*zemirah* זְמִירָה
Sabbath songs and hymns, "table songs"	*zemirot* זְמִירוֹת
sing	*shar* שָׁר
song, poem	*shir* שִׁיר
	shirah שִׁירָה
O, Sing unto the Lord a new song.	שִׁירוּ לַיהוָה שִׁיר חָדָשׁ. *Shiru ladonai shir chadash.*

71 Singing Praises

Not all of the *shirim*, songs, in the Book of Psalms are joyous. Psalm 137, for example, records a tragic scene. The Jewish captives by the rivers of Babylon are told by their tormentors: *Shiru lanu mi-shir Tsiyon*, Sing us one of the songs of Zion. The Jewish exiles refuse, saying: *Ech nashir et shir Adonai al admat nechar?* How shall we sing the Lord's song in a foreign land?

The one hundred and fifty *tehilim*, psalms, collected in the Book of Psalms cover an enormous range of human emotion, from deepest sorrow (e.g., Psalm 137) to ecstatic joy (e.g., Psalm 150), from serene confidence (e.g., Psalm 23) to savage anger (e.g., Psalm 137:7-9). The Hebrew word, *tehilah* (plural, *tehilim*), actually means a "song of praise." The Hebrew word for "praise" is *hallel* or *hillel*, both spelled with the consonants *hei-lamed-lamed*. The Book of Psalms, *Tehilim* in Hebrew or *Tilim* in Yiddish, contains praises that were meant to be sung. The word "psalm" comes to us from the Greek *psalmos*, a "song sung to a stringed instrument." The opening line often tells us what the song is (e.g., Psalm 15, *Mizmor le-David*, "A Psalm of David") or instructs the choir or orchestra leader about the instruments to be used (e.g., Psalm 76).

A number of psalms begin with the exclamatory word, *Halleluyah*, literally, "*Hallelu*, Praise ye," and "*Yah*, the Lord." Psalms 113-118 constitute the *Hallel*, a liturgical group of praises of thanksgiving that are recited in the synagogue on all major festivals.

The marvelous Hallelujah psalms express some of the most sublime ideas in the history of human thought and in language that is unmatched for beauty in all of world literature. Even if you read the Hallelujah psalms as pure poetry, without music, a sense of exaltation will lift you upward. Few people can read Psalm 150, for example, without hearing the crashing cymbals and the soaring crescendo of orchestra and voices that fill the whole universe with praise!

הַלְלוּיָה 71

Hebrew root: ל-ל-ה

Sing us one of the songs of Zion.	שִׁירוּ לָנוּ מִשִּׁיר צִיּוֹן.
	Shiru lanu mi-shir Tsiyon.
How shall we sing the Lord's song in a foreign land?	אֵיךְ נָשִׁיר אֶת שִׁיר יְהֹוָה עַל אַדְמַת נֵכָר?
	Ech nashir et shir Adonai al admat nechar?
song of praise	תְּהִלָּה *tehilah*
Book of Psalms	תְּהִלִּים *Tehilim* or *Tilim* (Yiddish)
song [psalm] of praise	מִזְמוֹר *mizmor*
praise	הַלֵּל *hallel*
	הִלֵּל *hillel*
psalm of David	מִזְמוֹר לְדָוִד *mizmor le-David*
Hallelujah: Praise ye the Lord	הַלְלוּיָה *Halleluyah*
Hallel: a liturgical group of praises (Psalms 113-118) recited on all major Jewish festivals	הַלֵּל *Hallel*

72 Come, Let Us Sing!

In addition to the three clusters of musical words we have just studied—*shir*, song, poem; *zemirah*, song, hymn; and *tehilah*, psalm, song of praise—we also have two more word groups that resound with music. One group is based on the Hebrew root, *nun-gimel-nun*, from which we derive such words as *neginah*, music, song; *manginah*, song, melody; and the familiar *nigun*, melody, tune. Chasidic melodies—very often wordless—are *nigunim*.

The second word group is based on the Hebrew root, *resh-nun-nun*, which spells the Hebrew verb, *ranan*, cry or sing aloud. We have already learned some of the words based on this root in studying the "happiness" terms (see chapter 36). They include *renanah*, joyful music, songs of joy, and *rinah*, song, music. The verb, *ran* (rhymes with "non"), means to "sing, chant." The noun, *ron* (rhymes with "tone") means "song, music." Psalm 95 opens: *Lechu, neranenah ladonai*, O come, let us sing unto the Lord. Job 38:7 gives us the vivid words: *Be-ron yachad kochevei voker*, The morning stars sang together.

One of the shortest *tehilim*—Psalm 126, which is a *Shir ha-Ma'alot*—is one of the most joyous of all psalms, the "happy ending" to the infinitely sad Psalm 137. Israeli Prime Minister Menachem Begin recited Psalm 126 on March 26, 1979, when he signed the Camp David peace accords with Egypt on the White House lawn. It is beautiful both in Hebrew and in English and should have an honored place in every Jewish lexicon. Psalm 126 reads:

> When the Lord brought back those that returned to Zion,
> We were like unto them that dream.
> Then was our mouth filled with laughter,
> And our tongue with *rinah*, singing;
> Then said they among the nations:
> "The Lord has done great things with these."
> The Lord has done great things with us;
> *Hayinu semechim*, We are rejoiced.
>
> Turn our captivity, O Lord,
> As the streams in the dry land.
> They that sow in tears
> Shall reap *be-rinah*, in joy.
> Though he goes on his way weeping that bears the measure of seed,
> He shall come home *ve-rinah*, with joy, bearing his sheaves.

72 לְכוּ, נְרַנְּנָה!

Hebrew roots: נ-ג-ן, ר-נ-ן

music, song	*neginah*	נְגִינָה
song, melody	*manginah*	מַנְגִינָה
melody, tune	*nigun*	נִגוּן
melodies, tunes	*nigunim*	נִגוּנִים
chasidic melodies	*nigunim*	נִגוּנִים
cry, sing aloud	*ranan*	רָנַן
joyful music, songs of joy	*renanah*	רְנָנָה
song, music	*rinah*	רִנָּה
sing, chant	*ran*	רַן
song, music	*ron*	רֹן

O come, let us sing unto the Lord.
לְכוּ, נְרַנְּנָה לַיהוָה.
Lechu, neranenah ladonai.

The morning stars sang together.
בְּרָן־יַחַד כּוֹכְבֵי בֹקֶר.
Be-ron yachad kochevei voker.

We are rejoiced.
הָיִינוּ שְׂמֵחִים. *Hayinu semechim.*

He shall come home with joy.
בֹּא יָבֹא בְרִנָּה.
Bo yavo ve-rinah.

Appendix

The Hebrew Alphabet

Pronunciation in English	Name of Letter	Hebrew Letter
*silent	alef אָלֶף	א
b	bet בֵּית	בּ
v	vet בֵית	ב
g (as in "get")	gimel גִּימֶל	ג
d	dalet דָּלֶת	ד
h	hei הֵא	ה
v	vav וָו	ו
z	zayin זַיִן	ז
ch (as in Scottish "loch")	chet חֵית	ח
t	tet טֵית	ט
y (as in "yet")	yod יוֹד	י
k	kaf כַּף	כּ
ch (as in German "ach")	chaf כַף	כ
ch (used only at the end of a word)	chaf sofit כַף סוֹפִית	ך
l	lamed לָמֶד	ל
m	mem מֵם	מ
m (used only at the end of a word)	mem sofit מֵם סוֹפִית	ם

*When the silent letters, *alef* and *ayin*, appear with a vowel sign, they assume the sound of that vowel.

Pronunciation in English	Name of Letter	Hebrew Letter
n	נוּן *nun*	נ
n (used only at the end of a word)	נוּן סוֹפִית *nun sofit*	ן
s	סָמֶךְ *samech*	ס
*silent	עַיִן *ayin*	ע
p	פֵּא *pei*	פ
f	פֵא *fei*	פ
f (used only at the end of a word)	פֵא סוֹפִית *fei sofit*	ף
ts (as in Russian "tsar")	צָדֵי *tsadei*	צ
ts (used only at the end of a word)	צָדֵי סוֹפִית *tsadei sofit*	ץ
k	קוֹף *kof*	ק
r	רֵישׁ *resh*	ר
sh	שִׁין *shin*	שׁ
s	שִׂין *sin*	שׂ
t	תָּו *tav*	ת

*When the silent letters, *alef* and *ayin*, appear with a vowel sign, they assume the sound of that vowel.

Hebrew Vowels and Diphthongs

The Sephardic pronunciation is generally used; any Ashkenazic pronunciation is marked by an asterisk.

 — ⲧ = *a* as in "father"

 ⲧ = *a* as in "father" but a shorter sound

 ⲧ = **a* as in "law"

 ו ‐ = *o* as in "cord"

 ו ‐ = **o* as in "toe"

 ו ‐ = *u* as in "rule"

 — ⲧ = *e* as in "get"

 ‐ = **e* as in "they"

 י‐ ⲧ = *i* as in "machine"

 י‐ י‐ = *ai* as in "aisle"

 וי = *oi* as in "oil"

 י‐ = *ei* as in "their"

 ‐ = the silent *sheva* marks the end of a syllable

 ‐ = the vocal *sheva*, sounded as *e* in "the"

Bibliography

Ancient Israel. Harry M. Orlinsky. Ithaca: Cornell University Press, 1954.

A Basic Jewish Encyclopedia. Edited by Harry A. Cohen. Hartford: Hartmore Press, 1965.

A Book of Jewish Concepts. Philip Birnbaum. New York: Hebrew Publishing Company, 1964.

The Book of Psalms. Philadelphia: Jewish Publication Society of America, 1972.

Encyclopaedia Judaica. 16 vols. Jerusalem: Keter Publishing House Ltd., 1971.

The Ethics of the Talmud: Sayings of the Fathers. Edited by R. Travers Herford. New York: Schocken Books, 1945, 1962.

The Five Megilloth and the Book of Jonah. Philadelphia: Jewish Publication Society of America, 1969.

Gates of Prayer: The New Union Prayerbook. New York: Central Conference of American Rabbis, 1975.

Gates of Repentance: The New Union Prayerbook for the Days of Awe. New York: Central Conference of American Rabbis, 1978.

Gates of the House: The New Union Home Prayerbook. New York: Central Conference of American Rabbis, 1976.

Haggadah of Passover. Translated by Maurice Samuel. New York: Hebrew Publishing Company, 1942.

Heritage of Music. Judith Kaplan Eisenstein. New York: Union of American Hebrew Congregations, 1972.

The Holy Scriptures According to the Masoretic Text (1917 translation). 2 vols. Philadelphia: Jewish Publication Society of America, 1955.

In Praise of Yiddish. Maurice Samuel. Chicago: Cowles Book Company, 1971.

The Prophets: Nevi'im. Philadelphia: Jewish Publication Society of America, 1978.

A Rabbinic Anthology. Selected and arranged by C. G. Montefiore and H. Loewe. New York: Schocken Books, 1974.

The Torah: A Modern Commentary. W. Gunther Plaut and Bernard J. Bamberger. New York: Union of American Hebrew Congregations, 1981.

The Torah: The Five Books of Moses. Philadelphia: Jewish Publication Society of America, 1962.

A Treasury of Jewish Quotations. Edited by Joseph L. Baron. New York: Crown Publishers, Inc., 1956.

Quotations Used in the Lexicon

6 "Everyone curses me." *The Prophets: Nevi'im*, Jewish Publication Society (JPS), 1978, Jer. 15:10, p. 556

11 "Seek peace." *The Holy Scriptures*, JPS, 1955 (1917 translation), Ps. 34:15, p. 1588

12 "And turn in compassion to Jerusalem, Your city. Let there be peace in her gates, quietness in the hearts of her inhabitants." *Gates of Prayer*, Central Conference of American Rabbis (CCAR), 1975, p. 65

13 "Justice, justice shall you pursue." *The Torah*, JPS, 1962, Deut. 16:20, p. 356

14 "Love your neighbor as yourself." *The Torah*, Lev. 19:18, p. 217

14 "Love . . . the stranger." *The Holy Scriptures*, Deut. 10:19, p. 448

14 "You shall love the Lord your God with all your heart and with all your soul and with all your might." *The Torah*, Deut. 6:5, p. 336

16 "a reminder of the work of creation." *Gates of Prayer*, p. 719

16 "a remembrance of the Exodus from Egypt." *Gates of Prayer*, p. 719

16 "Remember the Sabbath day, to keep it holy." *The Holy Scriptures*, Exod. 20:8, p. 173

16 "Remember that you were a slave in the land of Egypt." *The Torah*, Deut. 5:15, pp. 334-335

16 "The memory of the righteous shall be for a blessing." *The Holy Scriptures*, Prov. 10:7, p. 1778

17 "compassionate and gracious." *The Torah*, Exod. 34:6, p. 161

17 "O God full of compassion." *Gates of the House*, CCAR, 1976, p. 185

19 "abundant in goodness and truth." *The Holy Scriptures*, Exod. 34:6, p. 210

19 "Speak the truth to one another, render true and perfect justice in your gates. And do not contrive evil against one another, and do not love perjury, because all those are things that I hate." *The Prophets: Nevi'im*, Zech. 8:16-17, p. 881

19 "Blessed is . . . the righteous Judge." *Gates of the House*, p. 129

20 "Only to do justice." *The Prophets: Nevi'im*, Micah 6:8, p. 840

20 "to judge the people." *The Holy Scriptures*, Exod. 18:13, p. 169

20 "men of truth." *The Holy Scriptures*, Exod. 18:21, p. 169

The number preceding each quotation indicates the chapter in which that quotation appears.

20 "And they judged the people at all seasons." *The Holy Scriptures*, Exod. 18:26, p. 170

20 "Give us a king to judge us." *The Holy Scriptures*, I. Sam. 8:6, p. 657

20 "Seek justice." *The Holy Scriptures*, Isa. 1:17, p. 951

21 "My days . . . are spent without hope." *The Holy Scriptures*, Job 7:6, p. 1855

21 "And you shall be secure because there is hope." *The Holy Scriptures*, Job 11:18, p. 1863

21 "And they shall come back from the land of the enemy. And there is hope for your future, says the Lord." *The Holy Scriptures*, Jer. 31: 16–17, p. 1205

21 "O my God, rescue me out of the hand of the wicked. . . . For You are my hope." *The Holy Scriptures*, Ps. 71: 4–5, p. 1641

21 "[Yet] our hope is not lost, / that hope of two millennia, / to be a free people in our land, / the land of Zion and Jerusalem." *Gates of Prayer*, p. 765

22 "Train up a child in the way he should go, / And even when he is old, he will not depart from it." *The Holy Scriptures*, Prov. 22:6, p. 1813

22 "What man is there that has built a new house and has not dedicated it? Let him go and return to his house, lest he die in the battle and another man dedicate it." *The Holy Scriptures*, Deut. 20:5, p.469

23 "Put not your trust in princes nor in the son of man [human beings]." *The Holy Scriptures*, Ps. 146:3, p. 1751

23 "Trust in the Lord, and do good." *The Holy Scriptures*, Ps. 37:3, p. 1592

23 "Those who trust in the Lord are like Mount Zion, that cannot be moved, enduring forever. Jerusalem, hills enfold it, and the Lord enfolds His people now and forever." *The Book of Psalms*, JPS, 1972, Ps. 125:1–2, p. 134

24 "Without knowledge, there is no understanding; without understanding, there is no knowledge." *Gates of Prayer*, Pirkei Avot 3:21, p. 22

24 "and all that could hear with understanding." *The Holy Scriptures*, Neh. 8:2, p. 2090

24 "I have given you a wise and an understanding heart." *The Holy Scriptures*, I Kings 3:12, p. 804

25 "Who are wise? Those who learn from all people [human beings]." *Gates of Prayer*, Pirkei Avot 4:1, pp. 22–23

25 "The spirit of wisdom and understanding . . . / The spirit of knowledge and of the fear [awe] of the Lord." *The Holy Scriptures*, Isa. 11:2, pp. 974–975

25 "But wisdom, where shall it be found? And where is the place of understanding?" *The Holy Scriptures*, Job 28:12, p. 1893

25 "Wisdom cries aloud in the street." *The Holy Scriptures*, Prov. 1:20, p. 1760

25 "The beginning of wisdom is: Get wisdom." *The Holy Scriptures*, Prov. 4:7, p. 1766

25 "woman of valor." *The Holy Scriptures*, Prov. 31:10, p. 1838

25 "She opens her mouth with wisdom." *The Holy Scriptures*, Prov. 31:26, p. 1839

25 "So teach us to number our days, / That we may get us a heart of wisdom." *The Holy Scriptures*, Ps. 90:12, p. 1675

26 "Because there is no truth, nor mercy, / Nor knowledge of God in the land." *The Holy Scriptures*, Hos. 4:1, p. 1416

26 "Then the Lord answered Job out of the whirlwind, and said: / 'Who is this that darkens counsel / By words without knowledge?'" *The Holy Scriptures*, Job 38:1-2, p. 1915

26 "the tree of the knowledge of good and evil." *The Holy Scriptures*, Gen. 2:17, p. 5

26 "Now there arose a new king over Egypt, who knew not Joseph." *The Holy Scriptures*, Exod. 1:8, p. 125

26 "You shall not oppress a stranger, for you know the feelings of the stranger, having yourselves been strangers in the land of Egypt." *The Torah*, Exod. 23:9, p. 140

26 "And there has not arisen a prophet since in Israel like Moses, whom the Lord knew face to face." *The Holy Scriptures*, Deut. 34:10, p. 511

26 "And the man knew Eve his wife; and she conceived and bore Cain." *The Holy Scriptures*, Gen. 4:1, p. 7

27 "proclaim liberty throughout the land." *The Holy Scriptures*, Lev. 25:10, p. 296

27 "Sound the great horn to proclaim freedom. . . . Let the song of liberty be heard in the four corners of the earth." *Gates of Prayer*, p. 41

27 "to be a free people in our land." *Gates of Prayer*, Ha-Tikvah, p. 765

28 "bone of my bones." *The Holy Scriptures*, Gen. 2:23, p. 5

29 "Honor your father and your mother." *The Torah*, Exod. 20:12, p. 134

29 "I am slow of speech and slow of tongue." *The Torah*, Exod. 4:10, p. 104

29 "Who is honored [respected]? One who honors [respects all] mankind [humankind]." *Pirkei Avot (Sayings of the Fathers)*, R. Travers Herford, Schocken, 1962, 4:1, p. 95

29 "Honor flees from one who runs after it and follows one who flees from it." Attributed to Elijah HaCohen, *Shebet Musar*, ch. 17, 1712, in *A Treasury of Jewish Quotations*, J. Baron, Crown, 1965, p. 186

30 "Who are strong? Those who control their passions." *Gates of Prayer*, Pirkei Avot 4:1, p. 23

30 "How are the mighty fallen!" *The Holy Scriptures*, II Sam. 1:19, p. 724

30 "the man raised on high." *The Holy Scriptures*, II Sam. 23:1, p. 785

30 "a mighty man of valor." *The Holy Scriptures*, Ruth 2:1, p. 1944

30 "In every age a hero or sage / Came to our aid." *Gates of Prayer*, Mi Yimalel, pp. 757-758

31 "And there was evening and there was morning, a first day." *The Torah*, Gen. 1:5, p. 3

32 "I have never called my wife 'wife', but 'home'." Attributed to Jose ben Halafta, Shabbat 118 b, in *A Treasury of Jewish Quotations*, p. 542

33 "God of all generations." *Gates of Prayer*, p. 134

33 "Source of mercy." *Gates of Prayer*, p. 302

34 "Behold, how good and how pleasant it is / For brethren to dwell together in unity!" *The Holy Scriptures*, Ps. 133:1, p. 1736

34 "And, behold, I am with you." *The Holy Scriptures*, Gen. 28:15, p. 63

34 "And, behold, it was very good." *The Holy Scriptures*, Gen. 1:31, p. 3

38 "'Let there be light.' And there was light." *The Holy Scriptures*, Gen. 1:3, p. 1

38 "the greater light . . . the lesser light." *The Holy Scriptures*, Gen. 1:16, p. 2

38 "a lamp to burn continually." *The Holy Scriptures*, Exod. 27:20, p. 191

40 "You shall not go up and down as a talebearer among your people." *The Holy Scriptures*, Lev. 19:16, p. 281

42 "Israel, My servant." *The Holy Scriptures*, Isa. 41:8, p. 1044

42 "with hard service." *The Holy Scriptures*, Exod. 1:14, p. 126

42 "Let heavier work be laid upon the men." *The Holy Scriptures*, Exod. 5:9, p. 134

42 "and to love Him, and to serve the Lord." *The Holy Scriptures*, Deut. 10:12, p. 447

42 "Receive our prayers with love." *Gates of Prayer*, p. 137

42 "You shall not . . . serve them." *The Torah*, Exod. 20:5, p. 134

43 "All that the Lord hath spoken will we do and obey." *The Holy Scriptures*, Exod. 24:7, p 182.

43 "The Israelite people shall keep the Sabbath . . . throughout the ages as a covenant for all time." *The Torah*, Exod. 31:16, p. 157

44 "the supreme King of kings." *Gates of Prayer*, p. 178

44 "we have no King but You." *Gates of Prayer*, p. 297

44 "Blessed is His glorious kingdom for ever and ever." *Gates of Prayer*, p. 224

44 "make us a king to judge us like all the nations." *The Holy Scriptures*, I Sam. 8:5, p. 657

44 "make them a king." *The Holy Scriptures*, I Sam. 8:22, p. 658

45 "Holy, holy, holy is the Lord of hosts; / The whole earth is full of His glory." *The Holy Scriptures*, Isa. 6:3, p. 962

45 "We sanctify Your name." *Gates of Prayer*, p. 79

45 "Let the glory of God be extolled, let His great name be hallowed." *Gates of Prayer*, Mourner's Kaddish, p. 629

46 "by whose mitzvot we are hallowed." *Gates of the House*, p. 41

47 "You shall be holy; for I the Lord your God am holy." *The Holy Scriptures*, Lev. 19:2, p. 280

47 "and you shall be unto Me a kingdom of priests and a holy nation." *The Holy Scriptures*, Exod. 19:6, p. 170

47 "You shall be something special." *The Torah: A Modern Commentary*, Union of American Hebrew Congregations (UAHC), 1981, commentary on Lev. 19:2

47 "I have set you apart from other peoples to be Mine." *The Torah*, Lev. 20:26, p. 220

48 "Hear our voice . . . for You are a God who hears prayer and supplication." *Gates of Prayer*, p. 42

48 "hear my prayer." *The Holy Scriptures*, Ps. 4:2, p. 1547

49 "We therefore bow in awe and thanksgiving before the One who is Sovereign over all, the Holy One, blessed be He." *Gates of Prayer*, p. 617

50 "Praise the Lord, to whom our praise is due! / Praised be the Lord, to whom our praise is due, now and for ever!" *Gates of Prayer*, p. 129

50 "Grant peace . . . goodness and blessing." *Gates of Prayer*, p. 376

52 "I believe with perfect [complete] faith in the Messiah's coming. And even if he be delayed, I will await him." *Gates of Prayer*, p. 753 (for text); *Heritage of Music*, J. Eisenstein, UAHC, 1972, p. 120 (for music)

52 "the steadfast God." *The Torah*, Deut. 7:9, p. 338

52 "And he believed in the Lord." *The Holy Scriptures*, Gen. 15:6, p. 28

52 "And . . . he put his trust in the Lord." *The Torah*, Gen. 15:6, p. 24

53 "separates sacred from profane, light from darkness, the seventh day of rest from the six days of labor." *Gates of Prayer*, p. 635

54 "Moreover, if the wicked man repents of all the sins that he committed and keeps all My laws and does what is just and right, he shall live; he shall not die. None of the transgressions he committed shall be remembered against him. . . . Is it My desire that a wicked man shall die?—says the Lord God. It is rather that he shall turn back from his ways and live." *The Prophets: Nevi'im*, Ezek. 18:21-23, p. 689

55 "Knowingly or not, the whole community of Israel and all who live among them have sinned; let them be forgiven." *Gates of Repentance*, CCAR, 1978, p. 252

55 "And the Lord said: 'I have pardoned in response to your plea'." *Gates of Repentance*, p. 253.

55 "For all these sins, O God of mercy, forgive us, pardon us, grant us atonement." *Gates of Repentance*, p. 329

55 "Forgive us, our Creator, when we have sinned; pardon us, our King, when we transgress; for You are a forgiving God. Blessed is the Lord, the gracious God, whose forgiveness is abundant." *Gates of Prayer*, p. 39

56 "All [everything] is foreseen, but free will [freedom of choice] is given." *Pirkei Avot* 3:19, p. 88

56 "I have put before you life and death, blessing and curse. Choose life." *The Torah*, Deut. 30:19, p. 382

56 "life and prosperity, death and adversity." *The Torah*, Deut. 30:15, p. 381

56 "Though God created the *yetser ha-ra*, He created the Law as an antidote against it." *Rabbinic Anthology*, Montefiore and Loewe, Schocken, 1974, Bab. B. 16a, p. 295

56 "If it were not for the *yetser ha-ra*, man would not build a house, or take a wife, or beget a child, or engage in business." *Rabbinic Anthology*, Gen. R. Bereshit 9:7, p. 305

57 "you have striven with beings divine and human, and have prevailed." *The Torah*, Gen. 32:29, p. 60

57 "May God rule." *The Torah: A Modern Commentary*, commentary on Gen. 32:4-33:17, "The Struggle"

59 "man from the dust of the earth." *The Torah*, Gen. 2:7, p. 5

59 "God fashioned [formed] an earthling from the earth." *The Torah: A Modern Commentary*, commentary on Gen. 2:7

59 "By the sweat of your brow / Shall you get bread to eat, / Until you return to the ground." *The Torah*, Gen. 3:19, p. 8

59 "tiller of the soil." *The Torah*, Gen. 4:2, p. 8

59 "from the fruit of the soil." *The Torah*, Gen. 4:3, p. 8

60 "your brother's blood cries out to Me from the ground." *The Torah*, Gen. 4:10, p. 9

60 "for the blood is the life, and you must not consume the life with the flesh." *The Torah*, Deut. 12:23, p. 349

60 "neither shall you stand idly by the blood of your neighbor." *The Holy Scriptures*, Lev. 19:16, p. 281

60 "You have shed blood abundantly . . . ; you shall not build a house to My name, because you have shed much blood." *The Holy Scriptures*, I Chron. 22:8, p. 2160

60 "this red, red pottage." *The Holy Scriptures*, Gen. 25:30, p. 55

61 "these are the names." *The Holy Scriptures*, Exod. 1:1, p. 125

61 "father of a multitude of nations." *The Holy Scriptures*, Gen. 17:4, p. 31

61 "son of my suffering [strength]." *The Torah*, Gen. 35:18, footnotes, p. 64

61 "son of the right hand [son of the south]." *The Torah: A Modern Commentary*, commentary on Gen. 35:18

62 "What is His name?" *The Torah*, Exod. 3:13, p. 102

63 "You shall [must] love the Lord your God with all your heart and with all your soul." *The Torah*, Deut. 6:5, p. 336

64 "God made the expanse." *The Torah*, Gen. 1:7, p. 3

64 "God made wild beasts." *The Torah*, Gen. 1:25, p. 4

64 "Let us make man in our image." *The Torah*, Gen. 1:26, p. 4

64 "And God saw all that He had made and found it very good." *The Torah*, Gen. 1:31, pp. 4-5

64 "How manifold are Your works, O Lord; in wisdom You have made them all." *Gates of Prayer*, p. 55

64 "doing wonders." *Gates of Prayer*, p. 59

64 "May He who causes peace to reign in the high heavens let peace descend on us, on all Israel." *Gates of Prayer*, p. 71

64 "the Lord, / Who made heaven and earth." *The Holy Scriptures*, Ps. 121:2, p. 1729

65 "Say little and do much." *Gates of Prayer*, Pirkei Avot 1:15, p. 18

65 "Better one hour of repentance and good works in this world than all the life of the world-to-come." *Gates of Prayer*, Pirkei Avot 4:22, p. 24

66 "ascending and descending." *The Holy Scriptures*, Gen. 28:12, p. 63

67 "and . . . for sending gifts." *The Five Megilloth and the Book of Jonah*, JPS, 1969, Esther 9:19, p. 108

67 "he [Noah] sent forth the dove." *The Holy Scriptures*, Gen. 8:8, p. 16

67 "and sent it by the hand of Uriah." *The Holy Scriptures*, II Sam. 11:14, p. 747

67 "Let My people go." *The Holy Scriptures*, Exod. 5:1, p. 134

68 "he [Cain] built a city." *The Holy Scriptures*, Gen. 4:17, p. 9

68 "[Noah] built an altar." *The Holy Scriptures*, Gen. 8:20, p. 16

68 "Come, let us build us a city." *The Holy Scriptures*, Gen. 11:4, p. 21

68 "Abraham built the altar there." *The Holy Scriptures*, Gen. 22:9, p.44

68 "And they built for Pharaoh store-cities [garrison cities], Pithom and Raamses." *The Holy Scriptures*, Exod. 1:11, pp. 125-126

About the Author

Edith Samuel was named director of the Department of Adult Jewish Studies of the Union of American Hebrew Congregations in July 1977, after having served for eighteen years as editor of the Union's much acclaimed youth periodical, *Keeping Posted*. Prior to joining the staff of the UAHC, Mrs. Samuel was a publicist for the American Jewish Congress and was formerly supervisor of "The Eternal Light" program of the Jewish Theological Seminary of America. A native of Atlantic City, New Jersey, she received her education at Antioch College, Yellow Springs, Ohio.

Mrs. Samuel edited two volumes of conversations on the Bible, *In the Beginning, Love* and *The Book of Praise*. The conversations were conducted between her late husband, Maurice Samuel, the noted author, lecturer, and Jewish scholar, and the late Mark Van Doren, the Pulitzer Prize poet and distinguished Columbia University professor. Their widely popular dialogues were aired nationally for twenty seasons on "The Eternal Light" radio and (later) television programs on the NBC network.

Edith Samuel passed away suddenly on December 23, 1980. This book is the legacy of her beautiful and sensitive soul.

Zichronah livrachah זִכְרוֹנָהּ לִבְרָכָה

May her memory be for blessing